Inventing the American Flag

Inventing the American Flag

HOW THE STARS AND STRIPES WAS WOVEN FROM SYMBOLS

Henry W. Moeller

Roaring Forties Press
1053 Santa Fe Avenue
Berkeley, CA 94706

www.roaringfortiespress.com

ISBN 978-1-9389017-8-2

Library of Congress Cataloging-in-Publication Data

Names: Moeller, Henry W., author.

Title: Inventing the American flag : how the Stars and Stripes was woven
 from symbols / Henry W. Moeller.
Other titles: How the Stars and Stripes was woven from symbols
Description: Berkeley, CA : Roaring Forties Press, 2019. | Includes
 bibliographical references and index. | Summary: "Vexillologists are not
 the only people who appreciate the flag--American flags are favored
 collectors' items for both history buffs and folk art aficionados. This
 book will appeal to all those markets. The abundance of art makes this
 an excellent gift book--it is a museum-quality book. The theory
 presented--that the symbols chosen for the flag were based on, among
 other things, ancient mythology, Christianity, and astronomy--is
 revolutionary. No one has ever woven all these elements together into
 one argument, which is so compelling that it seems perfectly obvious
 once it is unveiled"-- Provided by publisher.
Identifiers: LCCN 2019036888 | ISBN 9781938901782
Subjects: LCSH: Flags--United States--History. | Emblems, National--United
 States--History. | United States--Politics and government--Miscellanea.
 | United States--Symbolic representation.
Classification: LCC CR113 .M5197 2019 | DDC 929.9/20973--dc23
LC record available at https://lccn.loc.gov/2019036888

For my wife, Barbara

and our three sons—

Thomas, Russell, and Charles

All that mankind has done, thought, gained or been: it is lying as in magic preservation in the pages of books.

—Thomas Carlyle

Heroes and Hero-Worship: The Hero as Man of Letters

Contents

Preface

DESPITE BEING ONE OF THE MOST IMPORTANT BUILDINGS in the history of Western civilization, the Parthenon (built in 447–432 BC) in Athens is shrouded in mystery. "Never before in human history," writes Joan Bretton Connelly, "has there been a structure that is at once so visible to the world, so celebrated, so examined, so invested with authority, and yet, at the same time, so strangely impenetrable at its core."[i]

The American flag is much the same: an icon recognized around the world—celebrated, examined, invested with authority—and yet still an enigma.

Contemporary scholars who want to rediscover the original meaning of the Parthenon must try to see it as those who designed and constructed it saw it—to view it through the eyes of ancient Athenians. The same is true of the American flag: to recover the meaning of the earliest thirteen-star American flags, one must see them through the eyes of our nation's founders.

Unfortunately, that task became Herculean after the British army burned the Capitol and the President's House in August 1814, incinerating vast amounts of art, Revolutionary War memorabilia,

and documents from our nation's formative years. In the absence of so many primary sources, where can one turn for help in decoding early American flags?[ii]

Once again, the example of the Parthenon is instructive. Connelly argues that newly revealed traces of bright paint on architectural moldings set high within the Parthenon may be the key with which to unlock the original and hidden meaning of the temple. Similarly, as this book reveals, art is the most illuminating path to understanding our flag's early history.

After studying art in Italy and taking a "grand tour" of the continent in the 1760s, painter Benjamin West settled in London. There, the man who became known as the "father of American art" became part of an elite circle of politicians and artists. Virtually every notable American painter of West's time—Gilbert Charles Stuart, John Trumbull, Charles Willson Peale, Rembrandt Peale, John Singleton Copley, among others—traveled to West's studio in London for instruction in the arts and for his encouragement and support. They then returned to America, where, individually and collectively, they created our nation's nascent symbolism.[iii]

Looking at American history—and the American flag—through the lens of art is a new and eye-opening way of seeing how the American story unfolded. But perhaps we should not be surprised that art and the symbol of our nation are so intertwined. As John F. Kennedy declared in his inauguration speech, "the life of the arts, far from being an interruption, a distraction in the life of a nation, is very close to the center of a nation's purpose, and it is the test of the quality of a nation's civilization."[iv] It is a test that, as the following chapters explain, the new nation passed with flying colors.

Acknowledgments

I WOULD LIKE TO THANK the staffs of the following institutions for their help at various stages of this project: American Philosophical Society Library; Anglesey Abbey, England; Anne S. K. Brown Military Collection, Brown University; Bibliotheque Nationale; British Museum and British Library; Charleston Museum Library; Colonial Williamsburg; Connecticut Historical Society; Connecticut State Library; Donald W. Reynolds Museum and Education Center at George Washington's Mount Vernon Estate and Gardens; Dowling College; East Hampton Library; Flag Foundation; Fort Ticonderoga Museum; Free Library of Philadelphia; Hampton Bays Library; Historical Society of Pennsylvania Library; Huntington Library, Art Gallery and Botanical Gardens; Independence National Historical Park; J. Paul Getty Museum, Los Angeles and Malibu; John Carter Brown Library at Brown University; Library Company of Philadelphia; Library of Congress; Maryland Historical Society; Massachusetts Historical Society; Metropolitan Museum of Art; Monte Vista Homes; Morristown National Park Historical Park Library; Museum of the City of New York; Museum of the First Troop, Philadelphia, City Cavalry; National

Heritage Museum Library; Newberry Library; National Maritime Museum, Greenwich, England; New-York Historical Society; New York Public Library; New York State Library; Pierpont Morgan Library; Princeton University Library; Public Record Office, London, England; Rhode Island Historical Society; Rutgers University Library; San Francisco Public Library; San Francisco Theological Seminary; Star Spangled Banner House; Suffolk County Historical Society; SUNY at Stony Brook; Stanford University Libraries; Sutro Library; Trinity Wall Street Archives; University of California, Santa Cruz; University of Pennsylvania Libraries; US Military Academy Library and Museum at West Point; US Army Institute of Heraldry; US Supreme Court; Valley Forge Historical Society; Winterthur Museum and Library; Yale University Library.

Special thanks and appreciation go to Deirdre M. Greene, my editor, who went out of her way for many years to see that this book was properly and professionally constructed. Thank you, thank you, thank you! You have taught me a great deal—and always with kindness.

Thanks also to Nigel Quinney and Roaring Forties Press for the help in bringing this book to the world.

I want to make a special note of the help my friend and mentor Harold Langley provided. He has been a guiding force as the book evolved over the past two decades. He also knew how to boost my ego when my spirits were lagging.

Above and beyond their association with some of the aforementioned institutions, several individuals helped in ways that deserve special recognition. A few of these people are retired from their institutions, and some are now deceased, but I want the memory of their support to be preserved: Christopher Adde, Robert Allen, Betty Auten, Carl Baker, Carole Bos, Robert Bos, Karie Diethorn, Austin Eats, Neal Gabler, Robert Gianinni, Richard Gideon, Juan Gomez, Susan Green, Charles Greifenstein, Roy Goodman, Ken Haines, Mathew Hofstedt, Leslie Jobsky, Alan Jutzi, Edward B. Kaye, Cornelia King, Dorothy King, Susi Krasnoo, Tony La Bruna, Mark Leepson, Dan Lewis, Peter Orenski, Anthony Rosalia,

Charles E. Schumer, Pamela Scott, Julian Shapiro, Sylvester Simpkins, Ned Smith, William Stackhouse, Laura Stalker, Stephen Tabor, Sara Webber, David Zeidberg, and Linda Zoeckler.

I would also like to thank the following individuals who worked, tirelessly in some cases, to assist me during the research phases of this book: Nicholas Artimovich, Bruce Bazelon, Whitfield J. Bell, Mark M. Blair, Steven Boerner, Wallace Broege, Robert L. Caslen, Grace Cooper, Michael Crawford, Diana Dayton, Katherine Dirks, William Dudley, Sherrill Foster, Chris Fox, Chanan Greenberg, Erik Goldstein, Mike Hogan, Donald W. Holst, Sarah Jackson, Christian Johnson, Harry C. Jones, Cecile Kaufman, Larry Kelly, Lee Kennedy, Donald Kloster, Janet Larkin, Jack Lowe, Valerie-Ann Lutz, David Martucci, Elaine McConnell, Kevin Miller, Marla Miller, Christopher S. Morton, Elba Orsland, Diane Perry, Harold L. Peterson, Gina Piastuck, Maria Cristine Pirvu, Kathleen Richter, Robert Ritchie, Lynn St. John, Whitney Smith, Zach Studenroth, Susanne Garrison Terry, Gustave Tracchia, Alexandra Villing, Sally Webster, and Earl Williams.

PART 1

An Introduction

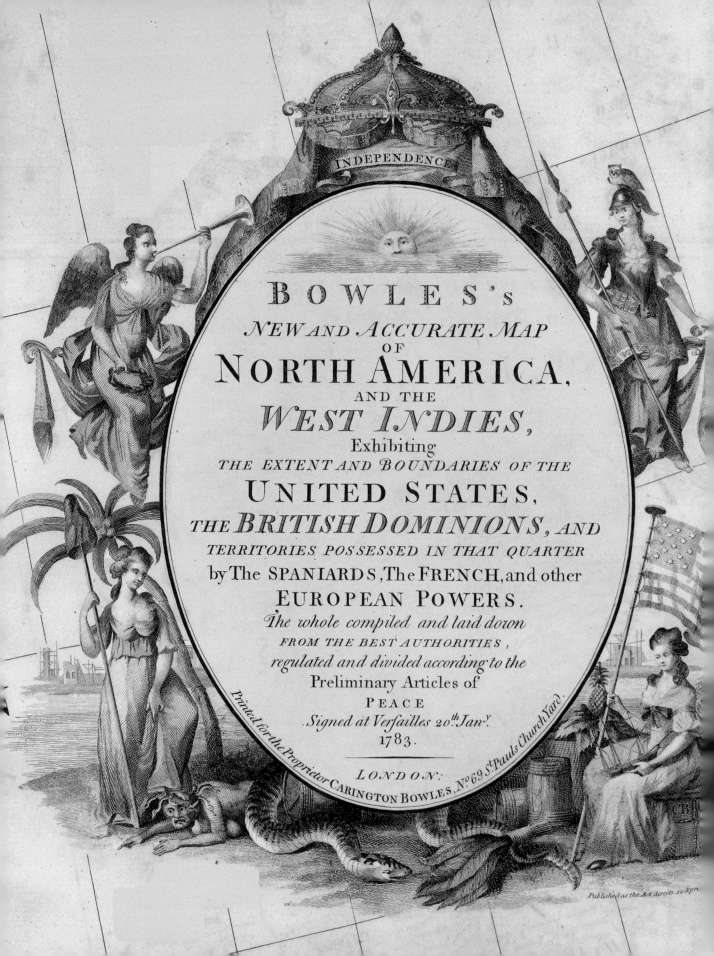

INDEPENDENCE

BOWLES's
NEW AND ACCURATE MAP
OF
NORTH AMERICA,
AND THE
WEST INDIES,
Exhibiting
THE EXTENT AND BOUNDARIES OF THE
UNITED STATES,
THE BRITISH DOMINIONS, AND
TERRITORIES POSSESSED IN THAT QUARTER
by The SPANIARDS, The FRENCH, and other
EUROPEAN POWERS.
The whole compiled and laid down
FROM THE BEST AUTHORITIES,
regulated and divided according to the
Preliminary Articles of
PEACE
Signed at Versailles 20th Jany.
1783.

Printed for the Proprietor CARINGTON BOWLES, No 69 St Pauls Church Yard.

LONDON.

Published as the Act directs 12 Apr.

CHAPTER 1

The Cultural Heritage of the Flag

AMERICANS REVERE their sovereign flag. Generations of American school children started their day with the Pledge of Allegiance to the flag—and they are not the only ones. The US House of Representatives institutionalized the practice in 1988; the US Senate adopted it in 1999. Since the Pledge of Allegiance was first published more than a century ago in *Youth's Companion* magazine, the level of tribute Americans bestow on their flag has risen substantially across all facets of the culture; consider, for example, the fact that spectators sing *The Star Spangled Banner* at most sporting events.[1]

The American flag is ubiquitous in daily life. Americans display their national flag more widely at home and abroad than any other nation. Yet, the American flag has aroused little intellectual curiosity throughout the years. Most of what Americans know about the history of the flag, they learned in grade school. And what they learned is incomplete, superficial, and inaccurate.

Even the youngest children know that Betsy Ross conferred with George Washington about the design of the first American flag. Unfortunately, few Americans know much more than this. The story as told begins and ends with Betsy Ross's design and

OPPOSITE: Detail from a map cartouche of North America from the Saint Lawrence River to northern Florida (1784). Upper left: winged Fame blowing trumpet. Upper right: Minerva, Roman goddess of wisdom and war, wearing a star gorget on chest. Lower right: America seated holding an American flag. Lower left: Goddess of Liberty holding a staff bearing a liberty cap. *(Courtesy of the John Carter Brown Library at Brown University.)*

construction of the flag that became our nation's symbol. Betsy Ross faces the same fate that has befallen many historical figures: her image is frozen in a moment of time. Meanwhile, the American flag has become a symbol that people use and manipulate for their own purposes.

In recent years, though, curiosity about the early history of the American flag has increased, and flags have become collectors' items as well as museum artifacts. Modern Americans are eager to understand the symbolism behind the stars and stripes. To make sense of this history, however, one must first deconstruct the myths surrounding the origin of the flag and construct a new

Parts of a Flag

The *hoist* is the part of a flag nearest the staff. The *fly* is the part of the flag opposite the hoist. A flag can be divided into four quarters (figure 1.1). The two quarters nearest the flagstaff are known as the *hoist quarters* (and more precisely still as the *upper* and *lower hoist*), while the two quarters nearest to the fly are known as the *fly quarters* (the *upper* and *lower fly*). The upper hoist quarter of the flag is the *canton*. The word *canton* is derived from a French word that originally meant a part of the corner. The canton is where the symbol of sovereign power or arms of a nation are displayed.[2] The canton of the modern American flag contains rows of white stars on a blue background.

The remaining three quarters of the flag are collectively known as the *field* of the flag. The field of the modern American flag contains thirteen alternating red and white stripes. On antique flags, a heading—a piece of heavy textile (e.g., linen)—may form a sleeve at the hoist edge.

When the flag is prepared for display, the sleeve is slid over a staff and the flag is secured to the staff by cords. When no sleeve is present, a cord is passed through hand-sewn grommets or reinforced eyelets on the flag's hoist. A cord is then passed through the grommets of the flag's hoist to secure the flag to the staff.

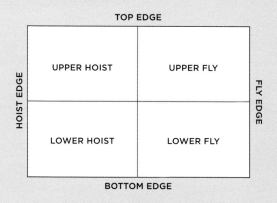

FIGURE 1.1. Parts of a flag.

paradigm. This book sets aside the Betsy Ross story and focuses on the sources and meanings of the symbols that make up the flag.

A New Paradigm

Although it is interesting to know who wrote the Declaration of Independence, that information pales in comparison to understanding the concepts the document expresses. The same is true of the American flag. This book explores the history of the symbolism of the flag in the early stages of its design, not who might have sewn it or who first placed the motifs on a textile. The focus here is on the symbolism conveyed by the thirteen-star American flag.

For most of the past two centuries, academics and historians have left the study of the American flag to groups such as the Daughters of the American Revolution, the American Legion, and military and patriotic organizations whose unstated mission is to promote patriotism, flag etiquette, and storytelling. Thanks to the efforts of these groups, most Americans today consider the flag a sacred object—a symbol deserving of reverence and respect.

But the flag was not always so revered. In fact, there is little historical record even to explain how it came to be. In 1909, flag historian George Canby wrote:

> It seems now almost incomprehensible that those of our forefathers who had the shaping of our destinies in their hands—that noble band of patriots, including the great Washington himself—should have left us with no records which tell us precisely how our flag came into existence. To this day the great majority of the American people are in ignorance of the real facts connected with its history. [3]

More than a century later, the above statement holds true. Marc Leepson notes: "Old Glory, in its unparalleled position as the symbol of the United States, has become one of the lasting legacies created by our Founding Fathers—even though we are not certain exactly which of those fathers (or mothers) conceived of the design." [4]

It is time to look at the American flag with a fresh perspective.

What Is a Symbol?

Thousands of years ago, humans placed an image on a piece of cloth and waved it for others to see. This cloth eventually became endowed with meaning; in the process, it became a symbol. The word *symbol* comes from the Greek word *symbolon,* which means token or pledge that stands for, represents, or suggests another thing, especially an object used to represent something abstract; or an emblem. For example, the dove is often a symbol of peace.[5] Anything can become a symbol: a word or a phrase, a person, a place, or a thing. According to Charles Elder and Robert Cobb, "an object becomes a symbol when people endow it with meaning, value, or significance."[6] Leslie White harkens back to John Locke's comment that symbols "have their signification from the arbitrary imposition of man" and notes that "a symbol may be defined as a thing the value or meaning of which is bestowed upon it by those who use it. . . . The meaning or value is in no instance derived from or determined by properties intrinsic in its physical form."[7]

A symbol, then, is a human invention and arises from the attribution of meaning to an object. A flag with stars in the canton and stripes in the field is a symbol of the United States of America. It is a material object that represents an abstract concept. A symbol is also a shape or sign used to represent something tangible such as an organization; the stars on the American flag represent the individual states in the union, and the stripes represent the original thirteen states.

Although symbols enable sovereign nations to distinguish themselves from others, a symbol has no meaning beyond that which an individual gives to it. This book focuses on social and political symbols of sovereignty—objects to which individuals singly and collectively attribute meaning.

Where Do Symbols Come From?

Every culture invents, borrows, adapts, or modifies symbols.[8] A culture invents new symbols when it finds existing symbols inadequate to "capture or give expression to their experiences, feelings, or

beliefs."[9] Symbols tend to be created when dramatic events or major changes are occurring in the political, social, or natural environment.

Who generates symbols? Symbols may evolve as a consequence of deliberate advocacy by political leaders, theologians, or artists. Politicians and theologians often need to rally support for their ideas and to distinguish themselves from their predecessors, and they use symbols to aid these efforts. By cloaking their mission or objectives in new symbolism, politicians and theologians thus garner support for the changes they are proposing.

Symbols may also arise from the need to communicate:

> It is this process of different individuals both singly and collectively attributing meaning to the same object that makes social communication possible. . . . Efficient communication requires that experience, knowledge, and feelings be summarized and condensed in readily recallable form. Symbols provide common reference points for categorizing shared information, values, or anxieties. New symbols are created to facilitate the recall of shared experiences and to communicate these experiences to others.[10]

Thesis of This Book

The symbolic origin of the American flag is an untold story that takes us from ancient Greece and Rome, to the birth of the Republic, from the Old World to the New, and from the esoteric mysteries of astronomy and heraldry to the ruggedly practical concerns of sailors and soldiers. After reading this book, you will have a new appreciation for the effort that went into creating our sovereign flag, what it signifies, and those who might have participated in its design.

The idea that one person in Philadelphia designed the US flag is embedded in American culture and tradition. The truth is much more complex and much more interesting, and reflects the inventiveness and independent spirit of America's founders. The voyage of discovery begins from a new port—it begins with the proposition that thirteen-star American flags evolved from four sources (Christianity, classical Greece and Rome, foundation myths, and

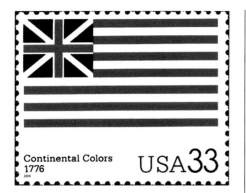

FIGURE 1.2. Continental Colors 1776, US postage stamp. (© 2000 United States Postal Service. All rights reserved. Used with permission.)

heraldry). The discussion moves to a consideration of different constellations on American flags, in particular, the sun—an American star—and the Milky Way.

This book covers some aspects of astronomical symbolism and answers some questions: Is the canton of stars on the American flag a heraldic symbol? Are the red and white stripes on the field of the American flag heraldic or nonheraldic? The book concludes with a brief analysis of the first sovereign flag and a discussion of some of the individuals who may have contributed directly or indirectly to the design of early American flags. But before embarking on this journey, let's briefly consider the earliest American flag.

In October 1775, the Continental Congress established the Naval Committee, forerunner of the Department of the Navy. Several weeks later, this committee ordered the fitting out of four ships for the protection and defense of the United Colonies. Thus began the US Navy.

Alfred was one of the first four ships chosen to serve in the Continental Navy of the United Colonies. She was also the first flagship of the American fleet, as well as the first ship to hoist the flag known as the Continental Colors (figure 1.2)[11] which was designated as the first unofficial national flag of the United States. The canton bears a union of the crosses of St. George and St. Andrew,[12] with a field of thirteen red and white stripes representing the United Colonies.[13] Howard M. Madaus and Whitney Smith point out that

> the Continental Colors served the United States as a naval ensign and as a garrison flag throughout 1776 and at least until September 1777, three months after the Stars and Stripes was adopted. It received the first salute to the American flag when the ship *Andrea Doria* was honored by Dutch authorities in the Caribbean in November 1776.[14]

Birth of the Modern Stars and Stripes

On July 2, 1776, the Second Continental Congress adopted a resolution declaring that the colonies "are, and of right ought to be,

free and independent States." Two days later, Congress approved the Declaration of Independence. As news of independence gradually reached the thirteen colonies, colonists burned British symbols in an exhibition of iconoclasm.[15]

Colonists were now free to create flags using symbols emblematic of their culture. But where would they find these symbols? How does a new nation in search of a cultural identity find it? How does a nation invent symbols that give expression to the general public's experiences, feelings, and beliefs? Who converted cherished beliefs into iconographic forms on banners that became symbolic of the new nation?

The Birth of the American Flag, as Proposed by Whitney Smith and Peter Orenski

"On 3 June 1777 the request of Thomas Green, an Indian, was set before the Continental Congress in Philadelphia. He wanted his American friends to present his tribe with the flag of their new nation, continuing a tradition started by the British and French in the early days of exploration. Two weeks later the Marine Committee of Congress resolved that "the Flag of the United States be 13 stripes alternate red and white, that the Union be 13 stars white in a blue field representing a new constellation."

"This flag, the first Stars and Stripes, was designed by Francis Hopkinson—a leading government official, heraldist, and poet. There is good reason to believe that Hopkinson's original concept showed the 13 stars in a ring to simulate the "new constellation" referred to by the law: symbolically, this saluted the United States as a new addition to the roster of independent nations in the world. Unfortunately, many early records have been lost and the full story of the first flag will probably never be known.

"Colors, i.e. flags carried by the army or militia, were usually made by painting designs on silk and a ring of 13 multipointed stars presented no difficulty. When sewn stars were required for naval flags made of bunting, however, it was considerably easier to arrange the stars in rows, thus beginning a tradition which continues today. Rows of 4-5-4 or of 3-2-3-2-3 stars became common for the 13-star flag, widely used on ships and forts.

"Betsy Ross was one of many women who sewed 13-star flags, but the claims of her family (first made in the 1870s) that George Washington had asked her to make the very first such flag are unproven and unlikely. The 13-star, 13-stripe flag was used by common citizens on land as well as at sea. This was contrary to the practice in other countries which considered every flag to be a symbol of the governing classes (the monarch, priests, and military). For this reason many vexillologists (flag scholars) consider the Stars and Stripes to be the world's first real national banner rather than simply one representing a government."[16]

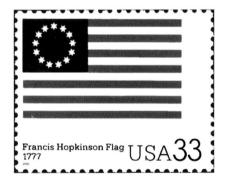

FIGURE 1.3. Francis Hopkinson Flag 1777, US postage stamp. (© 2000 United States Postal Service. All rights reserved. Used with permission.)

The Continental Congress took no immediate action to adopt a flag to represent the newly independent states, and would take no action on that front for eleven months.[17] Because of this lack of direction, there has been some controversy over the appearance and designer of the "first" American flag. Whitney Smith and Peter Orenski believe that the first American flag, designed by Francis Hopkinson, a leading government official, herald, and poet, had thirteen stars arranged in a circle (figure 1.3). Mark Leepson disagrees; he believes that Hopkinson designed a flag with thirteen stars arranged in rows in the canton and that Betsy Ross, a Philadelphia flag maker, designed a flag with stars in a circle.[18]

A (Not So) Revolutionary Definition of Astrology

Ancient astrologers believed that constellations or individual stars influenced the lives of humans. Today, the word *influence* often means "the power to produce effects."[19] But centuries ago, astrologers used *influence* as an astrological term: influence was a fluid emitted by the stars that affected both human and national life (figure 1.4).

This definition of influence is intrinsically tied to the definition of astrology. The *Oxford Dictionary* defines influence as "the flowing in of an ethereal fluid" from the stars—regarded as affecting human destiny. It is from Middle English and in turn from medieval Latin, *influentia*.[20]

In the eighteenth century, astrologists believed that the universe and all it contains was reflected in some manner not only on earth, but also in man and his works:

> The chief quest of all ages has been man's attempt to understand the mystery of existence and to find his place in it. . . . Not only have the stars guided the traveler on the earth and seas, but their constellations are archetypes that have been viewed as guides for the lives of man and nations.[21]

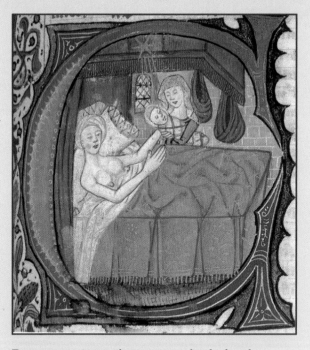

FIGURE 1.4. A star shining into a birth chamber, shedding its influence on a newborn child; detail from an Aratea illustrated manuscript (1490). (*The British Library Board, Arundel 66 f.148r.*)

Although both arguments have merits, the arrangement of the stars in the canton on the first American flag is in fact unknown. No primary records document the canton's appearance. All anyone knows with certainty is that the stars were arranged in the form of a constellation, per the Flag Resolution.

A New Constellation

An entry in the June 14, 1777, edition of the *Journal of the Continental Congress* reads:

> Resolved: that the flag of the United States be made of thirteen stripes, alternate red and white; that the union be thirteen stars, white in a blue field, representing a new constellation.[22]

At the time, a constellation was defined as "a cluster of fixed stars or an assemblage of splendors, or excellencies."[23] The term as used by the Continental Congress had three meanings:

- The new constellation would represent the union or confederation of states: each star and each stripe on the flag would represent one state.
- The newly formed United States was a new constellation, forged out of liberty and freedom. In becoming an independent nation, the United States was joining the older sovereign nations of the world.
- The constellation referred to the position of the stars in relation to an ascendant sign of the zodiac at the time of the nation's birth. In astrology, the constellation at one's conception or birth determines one's character and fate. Thus, the new constellation represented the future of the new nation.[24]

Yet, Congress did not specify which constellation would serve as a model for the new constellation. On July 9, 1777, Ezra Stiles (figure 1.5), a Portsmouth, New Hampshire Congregational minister, noted the creation of the new constellation in his diary: "The Congress have substituted a new Constella of 13 Stars (instead of the British Union) in the Continental Congress."[25] The choice of

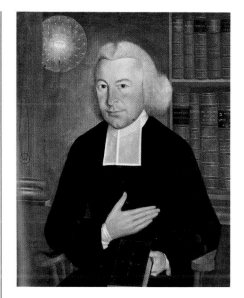

FIGURE 1.5. *Ezra Stiles* (1770–71), by Samuel King. *(Yale University Art Gallery, New Haven, CT. Bequest of Dr. Charles Jenkins Foote B.A. 1883, M.D. 1890.)*

stars to represent the nation must have pleased Stiles, who regularly spent nights peering through a telescope charting the courses of comets and ascertaining the dimensions of the aurora borealis.[26]

The concept of a new constellation as a symbol of the American union permeated revolutionary and postrevolutionary culture. Stiles used the phrase "new constellation" in a sermon before the Connecticut legislature on May 8, 1783; he applied the second meaning to the term: that of a new nation joining older sovereign nations. Thomas Jefferson used a similar meaning in his first inaugural speech in 1801.[27] Because the new constellation was not prescribed by law, it was altered frequently over the course of the next two decades.

CHAPTER *2*

Provenance of Early American Flags

I N THE ART and antique world, *provenance* is widely recognized as the history of ownership. It is also the place of origin or earliest known history of something's existence. This book uses the term provenance in regard to the origin of American flag symbols and the branches of knowledge from which these symbols arose.

Thirteen-star American flag symbolism evolved out of four disciplines: Christianity, classical Greece and Rome, foundation myths, and heraldry. These sources are introduced in this chapter and discussed in greater detail throughout this book.

Symbolic Source #1: Christianity

One foundation of American nationhood and a source on which American flag symbolism is based is Christianity. The pulpit paid steady attention to political discourse between 1730 and 1805. As political scientist Ellis Sandoz writes:

Preachers interpreted pragmatic events in terms of a political ideology imbued with philosophical and revelatory learning.

Their sermons also demonstrate the existence and effectiveness of a popular political culture that constantly assimilated the currently urgent political and constitutional issues to the profound insights of the Western spiritual and philosophical traditions. That culture's political theorizing within the compass of ultimate historical and metaphysical concerns gave clear contours to secular events in the minds of Americans of this vital era.

Religion gave birth to America, as de Tocqueville [author of *Democracy in America*] observed long ago. On the eve of the revolution in his last-ditch effort to stave off impending catastrophe, Edmund Burke reminded the [British] House of Commons of the inseparable alliance between liberty and religion among Englishmen in America. Mercy Otis Warren noted in her 1805 history of the American Revolution: "It must be acknowledged that the religious and moral character of Americans yet stands on a higher grade of excellence and purity, than that of most other nations." Of the Americans on the eve of the Revolution Carl Bridenbaugh has exclaimed, "who can deny that for them the very core of existence was their relation to God?"[28]

Today, clergy preach to their congregations in churches; elected officials serve their constituents in government-owned buildings. Church and state are theoretically separated by law. In the eighteenth century, however, this line was blurred. Sermons were regularly delivered to governors and legislatures in New England. To be chosen to deliver a sermon was an honor; the clergy provided a moral force that guided political discourse. As John Wingate Thornton wrote, "to the Pulpit . . . we owe the moral force which won our independence."[29]

Political sermons were published and widely distributed. One sermon that is considered one of the most famous of the time is "The Church's Flight into the Wilderness," delivered by Samuel Sherwood, a Presbyterian minister, to his congregation on January 17, 1776. In this speech, Sherwood introduced symbolic imagery from the Bible's book of Revelation, referring to the sun, the moon, and the stars as Christian symbols. Months later, some of these astronomical symbols would become part of American flag iconology.[30]

Sherwood may not have realized that astronomical symbolism had been used in art for millennia and featured prominently in Christian art. One example can be found in the Saint-Sever Beatus manuscript (figure 2.1), which contains the only complete text of the *Commentary of the Apocalypse* (Revelation) written by a Spanish monk, Beatus of Liebana, in 776. In the eleventh century (1028–1072), the manuscript was lavishly illustrated by the artist Stephanus Garsia and others under the direction of Gregorio Mutaner, abbot of Saint Sever in Gascony, France. One of Garsia's illustrations depicts a thirteen-star constellation with the same configuration as that of the first sovereign American flag.

FIGURE 2.1. Detail from *The Second Angel Blows His Trumpet,* an illustration of Revelation 8:8, from *Beatus of Liebana. (MS Latin 8878, folio 139v. Bibliothèque Nationale, Paris.)*

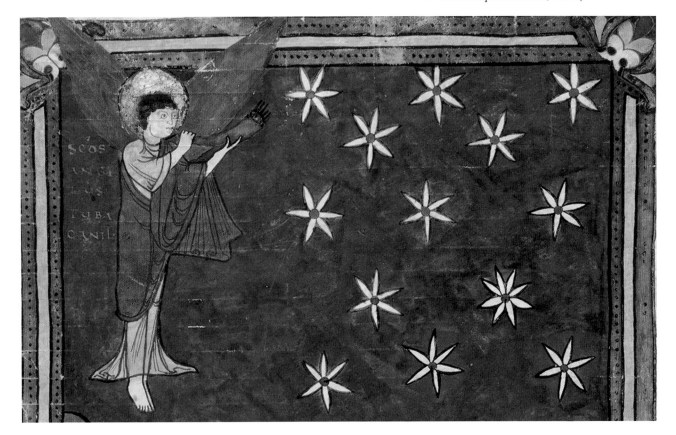

Symbolic Source #2:
Classical Greece and Rome

American founders were also influenced by the culture of classical Greece and Rome. This fascination continues today. In *The Birth of Classical Europe,* Simon Price and Peter Thonemann write:

> To an extraordinary extent we continue to live in the shadow of the classical world. At every level, from language to calendars to political systems, we are the descendants of a "classical Europe," using frames of reference created by ancient Mediterranean cultures. . . . This was no less true for the inhabitants of those classical civilizations themselves, whose myths, history, and buildings were an elaborate engagement with an already old and revered past—one filled with great leaders and writers, emigrations and battles. Indeed much of the reason we know so much about the classical past is because of the obsessive importance it held for so many Greeks and Romans, who interpreted and reinterpreted their changing casts of heroes and villains. Figures such as Alexander the Great and Augustus Caesar loom large in our imagination today, but they themselves were fascinated by what had preceded them.[31]

The classics occupied a privileged position in eighteenth-century American education. Greek and Roman authors such as Homer, Horace, Ovid, and Virgil had been at the heart of studies for hundreds of years, exerting a major influence on all aspects of culture. As Carl Richard posits:

> Intellectually, the founders knew the ancient world better perhaps than they knew the European or even the British world. The classics were both "a practical tool and a badge of gentility," providing the founders with "lessons of patriotism and statesmanship, models of pure taste in writing, and personal solace and inspiration."[32]

In the mid-eighteenth century, an understanding of classical symbols denoted class, taste, wisdom, and virtue. As American wealth and social mobility increased, knowledge of the classics became a means by which the rising middle class could acquire social status.

Aristocratic symbols were soon appropriated by middle-class figures, such as Benjamin Franklin, who sought social acceptance and, through it, political power. "The apt use of classical symbols identified one as a 'gentleman'—a man of leisure—a 'scholar' in the original Greek sense, 'one possessing leisure.' "[33]

> [American founders] loved and respected the classics for the same reason that other people love and respect other traditions—because the classical heritage gave them a sense of identity and purpose, binding them with one another and with their ancestors in a common struggle; and because it supplied them with the intellectual tools necessary to face a violent and uncertain world with some degree of confidence. Even when these tools failed to reflect reality they proved essential to the self-assurance and enthusiasm necessary for many of the founders' achievements. Throughout their lives, our founders continued to believe that the classics provided an indispensable training in virtue which society could abandon only at its own peril.[34]

The US founders hammered the concepts inherent in the classics into a variety of new shapes, often without fully appreciating the extent of their modifications.

Take, for example, the color of the Connecticut Second Continental Light Dragoons (figure 2.2). This flag has a field of thirteen red and white stripes and a central badge. A *badge* is a term originally applied to a distinctive and personal device worn by a ruler or knight for purposes of recognition.[35] It is an armorial device, not part of a coat of arms. Badges are worn on clothing or placed on flags.[36]

On this flag, the badge's interior comprises a thundercloud, lightning bolts, a pair of silver wings, and a golden scrolling ribbon with a Latin motto. The lightning bolt is commonly associated with Zeus, king of the Greek gods; this was his weapon of choice. The lightning bolt is also an emblem of sovereignty: the wings on the lightning bolt represent power, speed, and victory. On this badge, the lightning bolts symbolize chance, destiny, and providence—forces that mold the future.[37] This flag was captured by Banastre Tarleton, a British army officer at Pound Ridge, New York, in July 1779.

FIGURE 2.2. The central badge of the
Second Continental Dragoons color.
(Courtesy Sotheby's.)

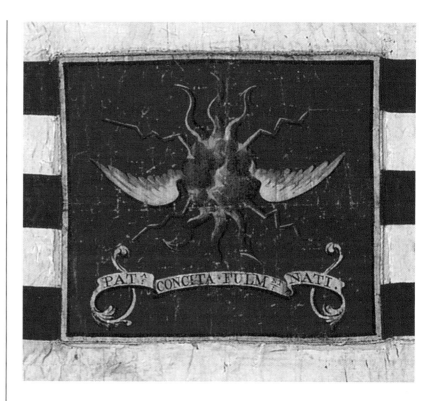

Symbolic Source #3:
Greek and Roman Foundation Myths

America's founders believed the primary builder of their nation was divine and that their nation's blueprint was heavenly, but they also thought that mortals could play a role in the design—and governance—of the new nation.

One item in the founders' toolkit was the foundation myth. A foundation myth is a legend or fictionalized narrative that is elevated to a symbolic level to define the nation's founding. This myth may overdramatize true incidents, omit important historical details, or add details for which there is no evidence; or it might be a fictional account that no one takes as true literally, but that contains symbolic meaning. The US founders adopted a Greek foundation myth and a Roman foundation myth and repurposed elements of them to use as symbols—including on the American flag.

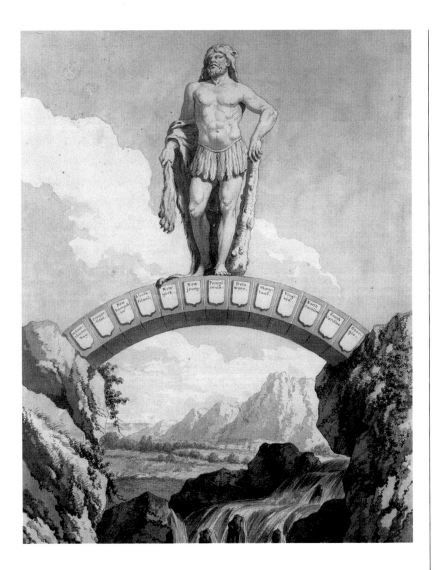

FIGURE 2.3. *Allegory of the American Union* (1784), by Francois Barbe-Marbois, shows Hercules on top of thirteen state shields. *(American Philosophical Society.)*

Heracles, as the Greeks called him, or Hercules, as the Romans called him, was considered a founder of Greece. He was a man of superhuman strength, courage, prowess, and fortitude—an agent of civilization and a protector of the state. The US founders used Hercules to foster a sense of identity and purpose that bound Americans with one another and with their Greek predecessors in their struggle to define a new society.

Heracles/Hercules is the subject of Francois Marbois's watercolor *Allegory of the American Union* (figure 2.3). Francois B. Marbois was

married to Elizabeth Moore, the daughter of American founder William Moore, a Revolutionary War–era governor of Pennsylvania.) Marbois depicts Hercules standing atop an arch displaying thirteen state shields. The arch symbolizes the zodiac, a constellation of stars that in turn symbolizes the sun.

US founders also mined myths about the founding of Rome, specifically as detailed in Virgil's classic poem *The Aeneid*. The protagonist is Aeneas, whom the ancient Romans viewed as the founder of their culture. Aeneas and his fellow Trojans were known for building the city of Rome, beginning shortly after its initial settlement by two brothers, Romulus and Remus.

Aeneas is a patriot who subordinates his personal goals to national interests. He is mindful of his duty, not only to the gods but also to his family and his country.[38] He fulfills his destiny: to establish Rome, the center of the greatest nation in civilization. Aeneas's characteristics resonated with American revolutionaries. He was a "sailor who struck out across dangerous, uncharted seas to discover a new land (Rome) in which to build a new civilization."[39]

But it is Aeneas's shield that American founders found most enticing. They borrowed symbolism from Aeneas's shield and deftly transplanted it onto an early version of an American coat of arms. This symbolism was later transferred onto the American flag, where it remains to this day.

Symbolic Source #4: European Heraldry

Using stars on a flag was not an American invention that occurred spontaneously in 1777. The symbolic origins of the stars and stripes are much older—what Americans now consider our most cherished symbols were borrowed from many other cultures. For example, in the archives at the Bibliothèque Nationale in Paris is a watercolor drawing of a shield with a star on a blue canton and a field of red and white stripes (figure 2.4). This fourteenth-century drawing was made in Sweden long before the arrival of Columbus in America.[40]

Two heraldic devices are present in figure 2.4. According to the *Oxford English Dictionary*, a *device* is a pattern or design, particularly

FIGURE 2.4. A fourteenth-century herald with a shield (coat of arms); detail from *Amorial de Bellenville (Bibliothèque Nationale, Paris, ms francais fol.5230.)*

a heraldic design or emblem, often combined with a motto. In figure 2.4, the three golden crowns on the herald's tabard are a device that represents the arms of King Arthur.[41] King Arthur is a mythological hero who first appeared in literature under the Latin name Artorius in the late seventh century. He led the British against the Saxons in twelve battles, culminating in the victory of Mons Badonicus in battles fought between 493 and 516.[42]

The other device in figure 2.4, and the one that is more pertinent to this discussion, is the shield on the left, with red and white stripes and a star in a blue canton. In 1147, Geoffrey of Monmouth wrote that Arthur's war shield was named Prydwenn ("blessed form"). On the inside of the shield was carved a likeness of Mary, the mother of Jesus.[43] The Greek and Roman goddesses Athena and Minerva were often represented by a star, and in medieval times, Mary assumed their attributes.[44] Because Mary is also known as *Stella Matutina,* "Star of the Morning," or *Stella Maris,* "Star of the Sea," the star on

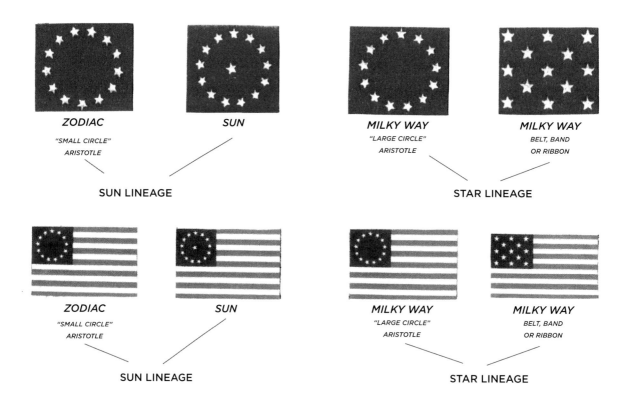

FIGURE 2.5. The earliest constellations used on thirteen-star American flags emerged from two separate lineages: a sun and stars.

the outside of the shield on the drawing can be considered a representation of Mary.[45] The shield thus depicts a star on a heavenly vault—a device that was repurposed and used on the first sovereign American flag.

A Story of Change

The symbols on the American flag have a provenance just as does the flag itself. The constellation on the American flag did not evolve from one tradition, but from two separate and distinct symbolic heritages: a sun and stars (figure 2.5). The next two chapters discuss the metamorphosis of American flag symbolism, and chapter 5 discusses a new constellation that evolved as the symbols changed.

PART 2

Sun and Star Motifs

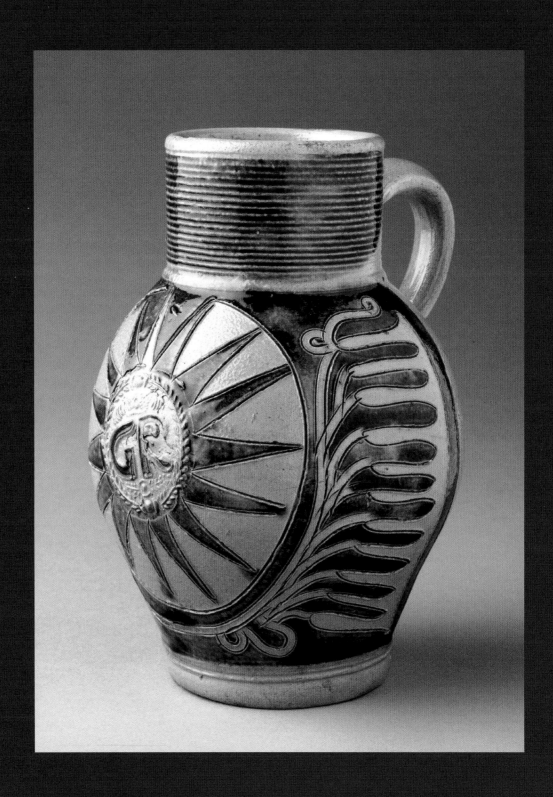

CHAPTER 3

The Sun: An American Star

WHEN THE American flag waves in the wind, a viewer's eyes are immediately drawn to the blue canton with white stars that makes up one-fifth of the flag's surface area. As most Americans know, one star is added to the canton each time a state is admitted to the union—thirty-seven stars have been added to the original thirteen-star flag. Every state's quest for statehood produced a large quantity of imagery as well as written documentation; consequently, historians are familiar with the frequent modifications to the flag's canton. The two exceptions are the first star—the American sun—and the earliest thirteen-star American flags.

A Symbol of Imperialism

Sir Isaac Newton's concept of the sun as the solar system's center and his description of the universal law of gravitation.[46] It provided a metaphor for writers who wished to link the political realm of the Hanoverian kings to scientific advancements. George I was the first English monarch to be identified as a sun king. His devoted followers viewed him as the focal point of his nation, the one who

OPPOSITE: Stoneware jug (see figure 3.1).

united all the rays of his people. "'The Beams of his Royal Goodness,' like those of the sun, had reached even 'these distant Regions where we dwell.' "[47]

The use of sun imagery to represent the king became popular during the reign of George II; many stoneware jugs and dishes bore the initials GR and the Roman numeral II, surrounded by a border of sun rays (figure 3.1). Upon the death of George II in 1760, a Pennsylvania mourner described him as the "glorious sun." The tradition of linking the monarch to the sun did not die with George II—during the reign of George III, soon-to-be founding father Benjamin Rush described the king "as essential to political order as the Sun is to the order of our Solar System."[48]

As ideas of revolution took hold, colonists reconsidered the preponderant view that the king was the center of the political system and thus "above" the common man. As monarchical love turned to loathing in the early 1770s, Americans made strenuous efforts to annihilate imperial symbols. Revolutionaries embarked on an orgy of symbolic cleansing and iconoclastic violence, removing royal emblems inside churches, ripping down tavern signs, beheading royal statues, and toppling monuments honoring George III. By the time independence was declared, most of the symbolism that had sustained the monarchy had vanished.[49] Out of the ashes, a new symbolism would emerge.

Yet the revolutionaries did not discard all the old symbolism. As a symbol of birth for thousands of years, the sun was reinterpreted and repurposed by the founders.[50] They initially decided to retain sun symbolism while they crafted a union of thirteen free and independent states.[51]

An American Motif

The sun had been used as an American symbol as early as the 1720s. Philadelphia printer Samuel Keimer and his young employee Benjamin Franklin cut and cast a sun ornament for New Jersey paper currency in 1728.[52] Franklin used the sun as a motif again for his patented stove in 1744.[53] This astronomical symbol appears on

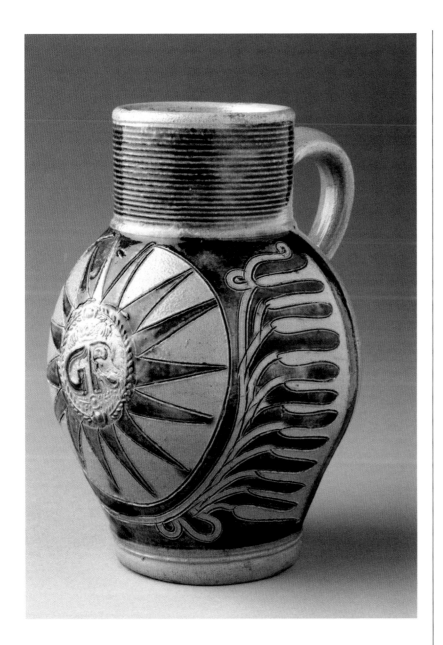

FIGURE 3.1. Stoneware jug (circa 1720–60). The king's initials and the words "George Rex" in the center of the sun denote George's place at the center of a political solar system. *(Courtesy Winterthur Museum, 1974.0035.)*

many objects used by the colonists and revolutionaries, including currency. For example, Continental currency with an emission date of February 17, 1776 (figure 3.2), features thirteen interlinked rings, a design attributed to Benjamin Franklin.[54] Each of the thirteen rings is inscribed with name of a colony. At the center

FIGURE 3.2. Continental paper currency: two-thirds of a dollar (February 17, 1776). *(Reproduced from the original, held by the Department of Special Collections of the Hesburgh Libraries of the University of Notre Dame.)*

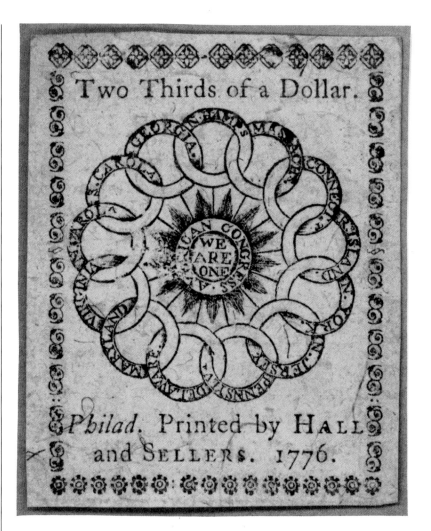

FIGURE 3.3. Image of America, detail from *Nouveaux Voyages aux Indes Occidentales*. *(The Huntington Library, San Marino, California, RB 32614 v.1.)*

of the design are the words "we are one" encircled by "American congress," surrounded by a sun motif.[55] The sun motif was also popular in print. The frontispiece of *Nouveaux Voyages aux Indes Occidentales*, a French book about the Americas, displays the sun's image on the chest of native American warrior (figure 3.3).

As the revolutionaries assessed how best to assert their power, they continued to employ sun symbolism. A significant feature in Carpenters' Hall in Philadelphia, site of the first session of the first Continental Congress in 1774, was a coat of arms carved out of wood bearing a rising sun with lines representing heat and light

radiating outward. This coat of arms, which represented divine providence, was a copy of the arms that served the Worshipful Company of Carpenters in London (figure 3.4).[56] A sun motif also appeared on a broadside declaring independence on July 4, 1776 (figure 3.5).

A rising sun was carved on the speaker's chair in the Pennsylvania Assembly at Independence Hall in Philadelphia (figure 3.6). George Washington used this mahogany armchair while he served as the presiding officer of the Constitutional Convention. (The chair was designed and made by John Folwell, a Philadelphia furniture maker who also designed the standard of the Philadelphia Light Horse Cavalry.[57]) In fact, the chair was in constant use during the Revolutionary War era. Benjamin Franklin remarked that during the stressful days of writing the constitution, he had doubts as to whether the sun was a "rising sun" or a "setting sun." At the conclusion of the Constitutional Convention in 1787, Franklin concluded that the chair did indeed depict a rising sun.[58]

Sun symbolism in the form of the eye of providence made it into a description of the celebration of the anniversary of independence

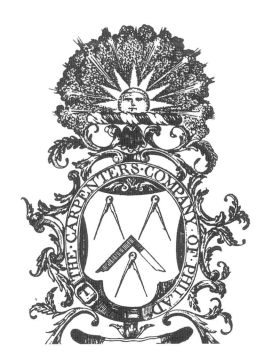

FIGURE 3.4. Carpenters' Company coat of arms. (*The Library Committee of the Carpenters' Company at Carpenters' Hall.*)

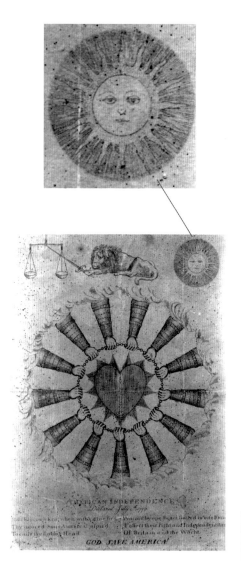

FIGURE 3.5. A sun motif in *American Independence Declared July 4th, 1776* (broadside). *(Courtesy Massachusetts Historical Society.)*

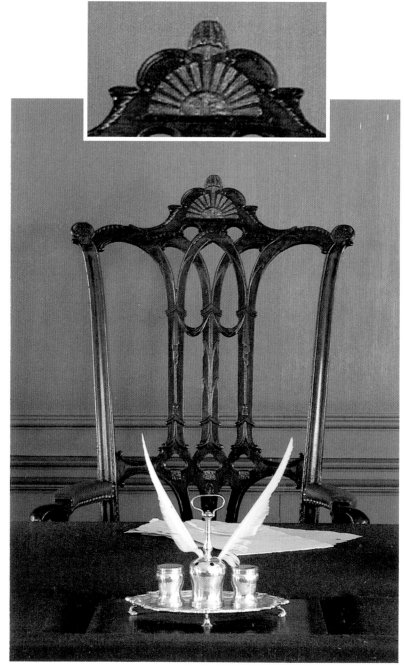

FIGURE 3.6. The Syng inkstand, used to sign the US Declaration of Independence, and the "Rising Sun" chair used by George Washington when he presided over the Constitutional Convention. *(Courtesy Independence National Historical Park.)*

on July 4, 1778 (figure 3.7). Rhode Island Congressman William Ellery recorded in his personal diary:

> The glorious fourth of July, I celebrated in the City Tavern [Philadelphia, Pennsylvania] with Brother Delegates of Congress and a number of other Gentlemen, amounting in the whole to about 80-the anniversary of Independency. The entertainment was elegant and well conducted. . . .
>
> At the head of the upper table and at the President's right hand stood a large baked Pudding, in the centre of which was planted a Staff on which was displayed a crimson Flag, in the midst of which was this emblematic device: An eye, denoting Providence [the sun], a Label in which was inscribed an appeal to heaven; a man with a drawn sword in one hand, and in the other the Declaration of Independence, and at his feet a scroll.[59]

Ideograms and Other Representations of the Sun

Almost every human culture has used representations of the sun as symbols, or ideograms. An ideogram is a written character symbolizing the idea of a thing without indicating the sounds used to say it. For example, a circle with a dot in the middle is an example of an ideogram of the sun (figure 3.8).

A circle without a dot in the middle (figure 3.9) is a different ideogram. This ideogram has two meanings: the zodiac and the Milky Way. (Milky Way symbolism is discussed in chapter 5.)

In *Meteorology*, Aristotle characterizes the zodiac as a small circle in the night sky and the Milky Way as a large circle in the night sky. His definition remained unchanged well into the nineteenth century.[60] Founders Benjamin Rush and Benjamin Franklin each owned a copy of Altieri's Italian and English dictionary, which defines the zodiac as a circle in the heavens.[61]

Two other ideograms were used in colonial America to signify the zodiac. One is an arch of stars.[62] The second is a band, or ribbon,

PHASE 1: SUN SYMBOLISM

SUN WITH THIRTEEN RAYS

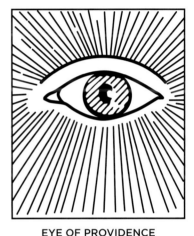

EYE OF PROVIDENCE

FIGURE 3.7. Two sun symbols used in the colonial period.

wrapped around the earth. Figure 3.10 depicts Atlas supporting the earth. The band wrapped around the earth is the zodiac. Michael Judge notes:

> The twelve constellations of the zodiac came to represent twelve distinct periods of the year, each of which began when the sun entered that particular constellation in its annual march. . . . These zodiacal signs were used by ancient astronomers to keep a complex . . . calendar. . . . They believed, as many still do, that each sign of the zodiac influences humans in a specific way.[63]

In certain depictions of the zodiac band, a star replaces the sign of the zodiac in each segment of the band. The symbol of twelve stars, evenly spaced in a band, has been used in art and astronomy by countless cultures. Thus, a circle of stars with a star in the center can be used to represent the sun, whereas a circle of stars with no star in the center can be used to represent the zodiac (figure 3.11).

As noted, the sun was a powerful symbol in colonial America. The first revolutionary flags used three constellations—a circle, a circle with a dot in the center, and an arch of stars—as symbols of the sun. The next chapter examines two specific ideograms that symbolized the sun on early American flags.

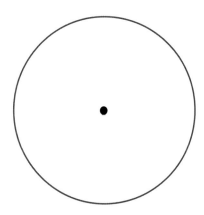

FIGURE 3.8. A circle with a dot at its center represents the sun. A Native American rock art example of this ideogram from Nevada is estimated to be eight thousand years old.

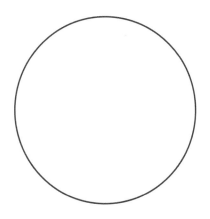

FIGURE 3.9. A circle represents the zodiac.

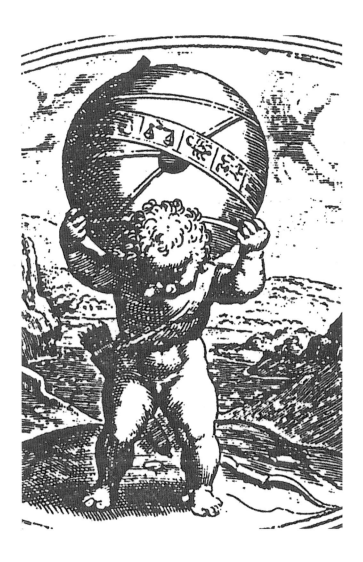

FIGURE 3.10. Atlas supports the earth, which displays a band representing the zodiac; detail from H. G. William Camden and Otto Van Veen, *The English Emblem Tradition* (Toronto: University of Toronto Press, 1998), p. 143. (*The Huntington Library, San Marino, California, PN 6351 E54.v4.*)

PHASE 2: STARS EMPLOYED TO SYMBOLIZE THE SUN

SUN SYMBOL
Twelve stars representing the sun

ZODIAC
Twelve stars representing the sun

FIGURE 3.11. *Top,* a sun ideogram with stars in a circle and one in the center; *bottom,* the zodiac (sun) with stars in a circle.

The Use of Stars to Represent the Sun

J UST AS CHRISTIANITY played a fundamental role in the rise of American nationhood, Christian art—particularly its representation of the zodiac—played an influential role in the development of the American flag.

Early Zodiac Symbolism

Ancient religions venerated the ties between mother and child, and early humans envisioned themselves as children of a maternal earth who nourished and sheltered them. The surface of the earth was thought to be the body of a great and powerful mother, from whose regenerative womb all plant and animal life emerged and into whose arms it returned in death.[64]

The ancients referred to the earth as the "great mother," the "mother goddess," "gaia," and the "queen of heaven." As a pagan symbol, the mother goddess dates to the early Stone Age, as evidenced by images on a Paleolithic mammoth tusk.[65] In later representations,

OPPOSITE: Detail from *George Washington at Princeton* (see figure 4.7).

the mother goddess wears a variety of headdresses: a tiara, a crown of stars, a mitre, and a Phrygian (liberty) cap. Starting in the fifth century B.C., the mother goddess was depicted wearing a crown of twelve stars that represented the zodiac.[66]

As Christianity took hold, it absorbed pagan elements of ancient zodiac symbolism.[67] The iconography of the Virgin Mary uses attributes of the mother goddess and harkens back to the Babylonian Damkina, mother of the young god Marduk and "queen of the heavenly tiara."[68] Marduk was the patron god of Babylon as described in the Babylonian myth the *Enuma Elish*.

Almost from its inception, the Christian church employed queen of heaven imagery; the walls of Roman catacombs constructed in the second century are lined with images of the queen of heaven, including one of the Madonna with child.[69] However, zodiac symbolism was not routinely used in conjunction with representations of Mary until the seventeenth century.

Zodiac Symbolism in the Christian Church

Even though zodiac symbols appear on the walls and floors of ancient synagogues, early Christians did not consider the zodiac a part of Christian symbolism, but rather a pagan symbol. But after the Arabs brought astrology to Europe, zodiac symbolism became popular with the masses. As a result, the Christian church was confronted with the concept of the influence of heavenly bodies (including the zodiac) on human destiny. By the Renaissance, the Roman Catholic church offered a compromise based on the beliefs of Saint Augustine:

> Saint Augustine had stated that it was perhaps not quite absurd to suppose that certain emanations from the stars might produce bodily differences in men, but that the volition of the soul was not subject to the constellations [like the zodiac]. This dictum strikes the keynote of Christian astrology: the stars exert their influence in accordance with the will of God. All earthly things are subject to their influence, but the soul of man, being divine,

is not, for the soul is not of earthly, but of heavenly nature. The stars may, it was admitted, exert an indirect influence on man's soul through his senses, and even on his will, which is an emanation of the soul, but the will itself is free and man is given the power of withstanding this influence. The stars do not compel, they only incline. The wise man will dominate the stars. These axioms, derived from Ptolemy, and frequently quoted by contemporaries of Shakespeare, proclaim the freedom of man's will and his power to master fate.[70]

Despite the Catholic church's unease with astrology as well as with the zodiac, as church dogma evolved, so did the church's iconology.[71] The Virgin Mary with a zodiac headdress appeared in the early seventeenth century after the issuance of a papal edict (bull) affirming the Doctrine of Immaculate Conception. This revision in Catholic doctrine resulted in a new representational form of art: Mary now was commonly depicted with a headdress with a zodiac motif (figure 4.1).

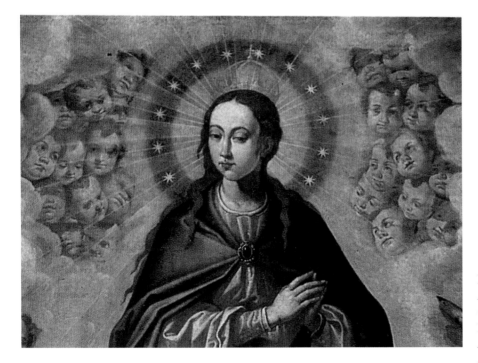

FIGURE 4.1. Detail from *Inmaculada con Miguel del Cid* (circa 1619), by Francisco Pacheco. *(SeFundacio Instituto Amatller de Arte Hispanico, Archivo Mas.)*

Anna Brownell Jameson, a religious scholar and art historian, writes:

> The first writer . . . [who] lays down specific rules from ecclesiastical authority for its proper treatment, is the Spanish [Francisco] Pacheco, who must have been forty years of age when the bull was published in 1618 [in Spain]. It is soon after this time that we first (learn) of pictures of the Immaculate Conception. Pacheco subsequently became a familiar of the Inquisition and wielded the authority of the holy office as inspector of sacred pictures; and in his *Arte de la Pintura,* published in 1649 he laid down those rules for the representation which had been generally, though not always exactly followed.[72]

The primary biblical source of the imagery used for the Immaculate Conception was Revelation, the final chapter of the New Testament. The word *revelation* means the uncovering or unveiling of information that has been hidden.[73] The images that appear in this chapter "are the universal images of the human race, the very stuff of our waking and sleeping dreams and nightmares."[74] Revelation is also a primary source of astronomical symbolism. Revelation 12:1 refers to Mary as the "woman of the apocalypse": "No earthly being, but a glorious astral, celestial being, a veritable Queen of Heaven."[75]

Jameson verifies the imagery the Catholic Church was trying to create:

> It is evident that the idea is taken from the woman in the Apocalypse, "clothed with the sun, having the moon under her feet and on her head a crown of twelve stars" [from Revelation]. The Virgin is to be portrayed in the first spring and bloom of youth as a maiden of about twelve or thirteen years of age; with "gravely sweet eyes'" her hair golden; her features "with all the beauty painting can express"; her hands to be folded on her bosom or joined in prayer. The sun is to be expressed by a flood of light around her. The moon under her feet is to have the horns pointing downward, because she is illuminated from above, and the twelve stars are to form a crown over her head . . . a celestial vision of the Madonna in her beatitude.[76]

Jesuit Henry Hawkins interpreted and translated Pacheco's doctrine into English and published his study as *Partheneia Sacra* (*Sacred Virginity*; figure 4.2). The 1633 book is a fusion of astronomical, devotional, and emblematic ideas that introduced zodiac crown symbolism to an English-speaking audience.[77] (For more information on emblems, see appendix A.)

FIGURE 4.2. Title page of *Partheneia Sacra* (1633), by Henry Hawkins. (*The Huntington Library, San Marino, California, RB 28933.*)

Migration to the Americas and Back Again

The image of a woman wearing a crown of stars made its way across the Atlantic. In 1708, Jean-Baptiste Franquelin, a Catholic French map maker who had lived in Canada, depicted the queen of heaven—or possibly the muse Urania—on the cartouche of a map of America. The queen wears a crown of stars (figure 4.3).[78]

In *To the Genius of Franklin*, an etching by Marguerite Gerard (figure 4.4), Benjamin Franklin is seated with Liberty at his side while the goddess Minerva shields them both from a battle raging on all sides.[79] In her right hand, Minerva holds a caduceus (a herald's wand traditionally associated with healing). Franklin is reaching for Minerva's left hand. Minerva symbolizes France at a time when the Colonies' reliance on French support was of paramount importance to the success of the American Revolution. Liberty holds a broken pillar—a symbol of death or chaos—in her left hand; her right hand

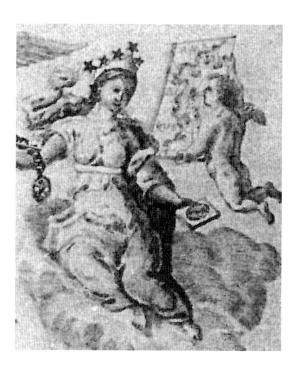

FIGURE 4.3. Cartouche from a French map of America (1708), by Jean-Baptiste Franquelin. *(Bibliotheque Nationale Paris.)*

FIGURE 4.4. Detail from *To the Genius of Franklin* (1778), etching by Marguerite Gerard, created under the direction of her brother-in-law, Jean-Honoré Fragonard. *(Courtesy Winterthur Museum, 1972.0161.)*

rests on Franklin's knee. She is wearing a crown of stars. Benjamin Franklin is reported to have seen this engraving during a visit to the Louvre; in any case, Liberty's crown of stars became a powerful political symbol for the American revolutionaries.[80]

A Definition of Transmutation

Transmutation is the act of changing from one form, state, or condition to another. The sun is a transmutable astronomical body. When it is viewed from earth, it is a sun, but when it is observed from far away in space, it is a star. In effect, the sun is a dual symbol, one capable of transmuting into a star.

The Zodiac During the Revolutionary War

In the spring of 1776, Connecticut pastor Samuel Sherwood delivered a sermon titled "The Church's Flight into the Wilderness." Sherwood's discourse became one of the most famous and popular political sermons of its day. His inspiration was Revelation, particularly Revelation 12:1–2, which describes a woman "cloathed with the sun and having the moon under her feet, and upon her head a crown of twelve stars."[81] Sherwood used this verse to compare and contrast the revolutionary cause to the apocalypse; as the founders plunged into the turmoil of war, the end of the world as they knew it was at hand. Although Sherwood intended the woman with a crown to represent the American church, as the sermon was disseminated and the colonists declared independence from Great Britain, the woman came to signify the United Colonies.

Another pastor used the symbol of a woman crowned with stars. On May 8, 1783, Ezra Stiles, president of Yale College, addressed the Connecticut General Assembly to celebrate the election of Jonathan Trumbull as governor. As the basis of his sermon, Stiles selected the same verse that Sherwood had chosen in 1776: "that a woman clothed with the Sun, and the moon under her feet, and upon her head a crown of twelve stars should flee into the wilderness." In the published version of the sermon, *The United States Elevated to Glory and Honor*, Stiles embedded an asterisk in the text after the word "twelve stars"; in the associated footnote, he

wrote "*Not to Say Thirteen" [stars]. Stiles referred to these thirteen stars as the new constellation of the United States.[82]

In between Sherwood's 1776 sermon and Stiles's 1783 sermon, a circle of stars was transformed from a symbol of the sun to a symbol of a new constellation (figure 4.5). In other words, America's sun of 1776 (the zodiac with twelve stars) transmuted into a new constellation of thirteen stars, each representing one colony.

Sun Imagery on America's Earliest Flags

Because the sun motif was so common in eighteenth-century American culture, it is no surprise that sun symbolism was a common motif on early American flags. On the standard of the Philadelphia Light Horse Cavalry, made from silk and dating from 1775 (figure 4.6), thirteen golden ribbons represent the petals of a sunflower that mimics the rays of the sun.

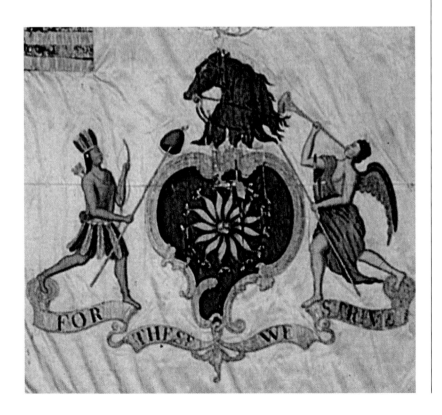

**PHASE 3:
A NEW CONSTELLATION**

FIGURE 4.5. A flag with thirteen stars that represent the new constellation, per the Flag Resolution of June 14, 1777.

FIGURE 4.6. Detail from standard of the Philadelphia Light Horse Cavalry (1775), designed by John Folwell. *(Museum of the First Troop Philadelphia City Cavalry.)*

An American flag with a sun motif appears in a painting by Charles Peale Polk (figure 4.7). He depicts the Battle of Princeton in January 1777, six months before the Flag Resolution was adopted. This seminal battle, in which General George Washington's forces defeated the British, so greatly bolstered the morale of the Continental forces that the event was widely commemorated in contemporary works of art.

FIGURE 4.7. Detail from *George Washington at Princeton* (circa 1788), by Charles Peale Polk with Charles Willson Peale. *(Indianapolis Museum of Art, Gift of Mr. and Mrs. Nicholas H. Noyes, 53.64.)*

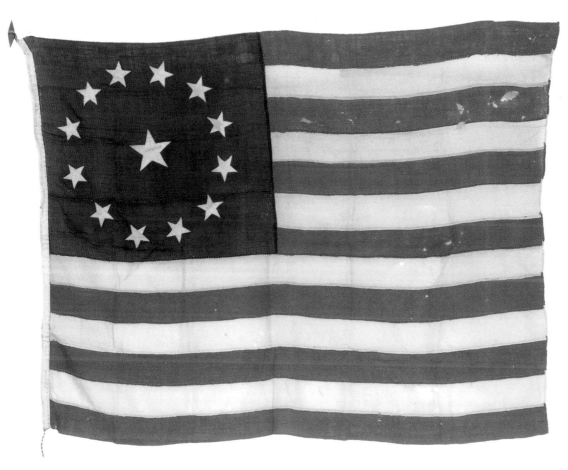

FIGURE 4.8. Third Maryland Flag, a nineteenth-century flag. *(Courtesy Sotheby's.)*

A sun-inspired canton known as the "Third Maryland" motif allegedly was used by a regiment of Maryland soldiers during the Revolutionary War (figure 4.8).[83] Dominic Serres, a founding member of the Royal Academy and Marine Painter to George III, painted a ring of twelve stars with a star in the center of an eighteenth-century canton design he thought was an early American naval flag.[84] An identical canton appears on a silk banner carried by the Society of Pewterers for a parade in New York that celebrated the ratification of the Constitution on July 23, 1788.

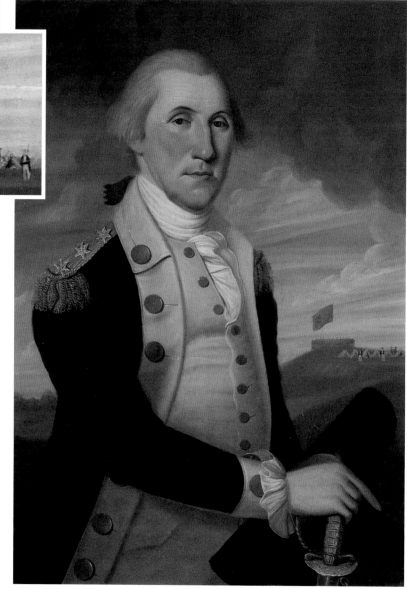

FIGURE 4.9. *George Washington as Commander-in-Chief of the Continental Army* (1790), by Charles Peale Polk. *(Courtesy Winterthur Museum, 1956.0562A.)*

In the background of Polk's 1790 *George Washington as Commander-in-Chief of the Continental Army* (figure 4.9), a flag with stars arranged in a circle flies over a fort. There is a white mark in the middle of the circle of stars, but one cannot say with certainty that it is a star.

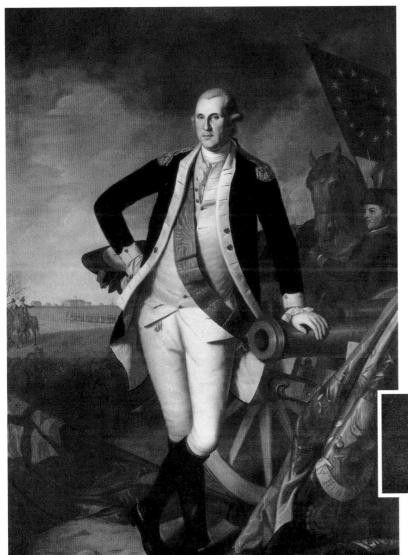

FIGURE 4.10. *George Washington at Princeton* (1779), by Charles Willson Peale. *(Private Collection/ Photo © Christie's Images/The Bridgeman Art Library.)*

A circle of stars representing the sun appears on a flag in Charles Willson Peale's *George Washington at Princeton* (figure 4.10). A professional artist as well as a soldier who fought in the Battle of Princeton, Peale painted eight portraits of the Battle of Princeton, a decisive moment in American history.[85] He had a thorough

understanding of flag symbolism, and he appears to have accurately painted the flag used by the American forces at Princeton. In this painting, a large blue flag in the background shows thirteen stars arranged in a circle.[86] The red and white stripes routinely found on the field of the American flag after June 14, 1777, are notably absent.

Summary

The earliest American flags used a circle of stars to represent the sun (a circle with a star in the center) or the zodiac (a simple circle of stars). This symbolism was rooted in the Christian tradition as well as in sun flag lineage. However, in the years immediately following the Flag Resolution, the symbols of the American flag underwent a transmutation. By late 1779 and no later than 1780, the nascent nation was using a new constellation of stars—the Milky Way. This became the symbol of choice for the canton of the thirteen-star American flag.

A New Constellation:
The Milky Way

THE CLASSICAL TRADITION was an important component of the cultural identity of the newly formed United States.[87] Privileged eighteenth-century Americans received a classical education based on the study of ancient Greece and Rome.[88] This heritage, and the myths drawn from it, gave the colonists a sense of identity and purpose that bound them with one another and with their ancestors in the struggle to define a new society.

A myth is a traditional story, especially one concerning the history of a people or explaining some natural or social phenomenon, and typically involving supernatural beings or events. Myths endure because the narrative is retold from generation to generation, becoming a part of the common culture. Myths express every kind of human emotion in an effort to explain the activities of life—including establishing a new nation.[89]

Rome had instituted a structure of government that the United States hoped to emulate, and as Americans set a course for themselves, they looked to classical mythology for inspiration. Because

America's founders in part envisioned their embryonic nation as the new Rome, they looked to foundation myths, especially myths about the foundation of Rome as recorded in Virgil's *Aeneid* and Livy's *History of Rome*. The US founders also focused on heroes popular in classical mythology, such as Hercules and Aeneas, and their roles as founders or protectors. Not only did foundation myths provide models for statesmen, they were also a source of American symbols.[90]

Founding of Rome Myths

Early American texts, religious discourses, and political writing were laden with elements of classicism. In particular, the founders relied on Roman foundation myths for inspiration on how to establish a new nation. Elements of these myths were repurposed and used as symbols by the newly independent states.[91]

One enduring foundation myth is that of twins Romulus and Remus. Their mother, a vestal virgin named Sylvia, explained her pregnancy by claiming she had been violated by Mars, the god of war. She was thrown into prison, and her newborn children were thrown into a river. They survived the attempted drowning and were found and suckled by a she-wolf. A herdsman discovered them, brought them home, and raised them. Romulus and Remus grew bold and strong and became leaders of men in the countryside. They eventually set out to found their own city on the Tiber.[92] Almost at once they disagreed about the site. Romulus wanted the city to be founded on Palantine Hill; Remus favored the Aventine; and each wished the city to be named for himself. A quarrel began, resulting in the murder of Remus by Romulus. Thus, Romulus acquired sole power, and the city was named Rome after its founder.

The US founders also studied the myth of Aeneas. In the *Aeneid*, Virgil's poem about the origins of Rome, Aeneas and his fellow Trojans build the city upon which Rome would eventually be founded. Although Aeneas did not found the city of Rome, the Romans viewed him as the founder of their race. As Book 8 of the *Aeneid* opens, Aeneas's two ships set off for the hills where one day

Rome will rise. Shortly after arriving in the new land, Aeneas falls asleep. The goddess Venus, his mother, persuades her husband, the blacksmith-god Vulcan, to make arms and a shield to protect her son. The shield, which was "dropped from heaven" by Venus, symbolizes the "story of Italy, Rome in all her triumphs."[93] According to heraldic scholar and author Sylvanus Morgan, Aeneas's shield represents Rome's fallen warriors and military heroes; this shield also represents the Milky Way.[94]

Robert Fagles, a modern translator of the *Aeneid,* notes that "the picture on the shield is another image of Rome's future. The incident is clearly modeled on the shield of Achilles in the *Iliad* (Book 18, 558–709). . . . Aeneas' shield is decorated with the deeds and names of those who through the ages have brought Rome to its position of world mastery."[95] The shield represents the future valor of warriors who would bring greatness to Rome through their heroic deeds: "And on this shield, there is the story of Italy, Rome in all her triumphs" (8.738–39).

As a patriotic Roman who subordinates his personal goals to national interests, Aeneas is mindful of his duty, not only to the gods but also to his family and to his country.[96] When Aeneas finally reaches his destination, he fulfills his destiny: to found Rome, the center of the greatest nation in civilization.

Aeneas's characteristics resonated with American revolutionaries. He was a "sailor who struck out across dangerous, uncharted seas in order to discover a new land [Rome] in which to build a new civilization."[97] This journey was widely celebrated in art. For example, in 1675, European artist Claude Lorrain depicted Aeneas's two ships arriving in Italy in *The Landing of Aeneas at Palanteum* (figure 5.1). In this painting, commissioned by Italy's Gasparo Altieri, one of the vessels is flying a blue ensign with stars on the masthead; the Altieri family claimed descent from Aeneas, and these stars mirror the stars on Aeneas's shield.[98]

Myth of Heracles/Hercules

Another myth that profoundly influenced colonial Americans was the legend of the man known to the Greeks as Heracles and to the

FIGURE 5.1. *The Landing of Aeneas at Palanteum* (1675), by Claude Lorrain. Note the blue ensign on the masthead of the ship in the background. *(© National Trust, Image #14908, Anglesey Abbey.)*

Romans as Hercules. The tale of a man of superhuman courage, prowess, and fortitude is entwined with legends about the creation of the Milky Way.[99]

The Greeks believed that Alcmene, the wife of Amphitryon, was a beautiful mortal. Zeus, king of the gods, wanted to sire a champion for both gods and men; while Amphitryon was off at war, Zeus visited Alcmene in the guise of her husband. Nine months later, Alcmene bore Heracles, son of Zeus.[100] Zeus's wife, Hera, was furious about his betrayal, and she turned her anger toward Heracles. Fearing that Hera would kill the unprotected baby, Zeus sent his messenger, Hermes, to bring the infant to safety under his own roof in Olympus. One night, Zeus lulled his wife to sleep and placed the baby at Hera's breast. The lusty infant woke Hera; she angrily pushed him away from her, her milk spraying across the heavens to become the Milky Way (figure 5.2). Pleased that his trick worked, Zeus returned the infant to Alcmene. His mortal son had suckled a goddess—Heracles would become immortal.

FIGURE 5.2. *The Origin of the Milky Way* (circa 1575), by Jacopo Tintoretto. *(© National Gallery, London/Art Resources, NY.)*

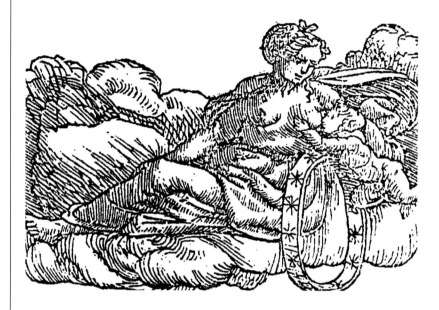

FIGURE 5.3. *Juno Nursing Hercules* (1546). Juno and Hercules are accompanied by a band, or ring, of stars representing the Milky Way. *(The Huntington Library, San Marino, California, PN6349.A4 1870.)*

The Roman myth has many of the same elements as the Greek myth. According to the Romans, the goddess Minerva, daughter of Jupiter (Zeus), was the protector of Hercules. Minerva devised a scheme to ensure Hercules's immortality. She guided Juno (the Roman equivalent of Hera) to the infant Hercules and persuaded Juno to put Hercules to her breast. Hercules sucked so violently that Juno's milk spurted across the heavens, where it became the Milky Way. Thus, Minerva, the goddess of war and wisdom, indirectly caused the creation of the Milky Way—in figure 5.3, the infant Hercules is being nursed by Juno; the pair is accompanied by a circle of stars that represents the Milky Way.[101]

Heracles/Hercules was a fitting role model for a newly independent country: born to a human mother and a father who was a god, he exhibits the characteristics of both mortals and gods. He is an agent of civilization and a protector of the state.[102] Greek and

Roman rulers often claimed a lineal descent to Heracles/Hercules to legitimize their aspirations to sovereignty, and he was adopted by both Greek and Roman city-states as a symbol of political power.[103] According to Marina Warner:

> Every Roman schoolboy was taught the legends of early history, which exemplified the virtues that the Romans liked to think were part of the essential Roman character, and stressed in particular the principle that the welfare of Rome must come before the desires of the individual; and even before loyalty to the family group.[104]

Early American Manifestations of Foundation Myths

Clearly, American revolutionaries drew insights from foundation myths on how to establish the new Rome. Classical mythology also provided a basis for the symbolism the founders selected to represent the new nation. Specifically, American colonists and revolutionaries relied on and repurposed the powerful blend of poetry and myth in the *Aeneid* and the Hercules myth. Virgil's shield and Hercules's Milky Way became raw materials for the colonists and revolutionaries as they created symbols.

For example, the Hercules myth appears in *American Instructor*, written by George Fisher and published by Benjamin Franklin and his partner, D. Hall (figure 5.4). They published this best seller three times (1742, 1748, and 1753).[105] A number of New England publishers republished the work in 1760, 1770, and 1776.

As one of the first actions after the United States declared independence from Great Britain in 1776, John Adams proposed a representation of Heracles/Hercules for use on the Great Seal. In an August 14, 1776, letter to his wife, Adams recounted his proposal, indicating that he was having second thoughts about it. He believed the imagery he wished to convey was too complicated for a seal, and the idea he wanted to develop was not original—he was uncomfortable borrowing images from other cultures.[106]

FIGURE 5.4. This Revolutionary-era best seller includes an image of Hercules and an account of the Milky Way. *(Special Collections, John D. Rockefeller, Jr. Library. The Colonial Williamsburg Foundation.)*

John Adams had a very different attitude than Benjamin Franklin, who had no qualms about borrowing symbols from other sources. Franklin clearly admired Hercules: in June 1775, Franklin described his grandson, William Bache, as the "strongest and stoutest Child of his age that I have seen: He seems an Infant Hercules."[107] Later, Franklin identified the United States' character and promise with the infant Hercules—a powerful youth—and used an image of Hercules in 1782 and 1783 for a medal known as the *Libertas Americana* (figure 5.5).

General Richard Montgomery died at the siege of Quebec on December 31, 1775. He was the first American general to die in the war. Three weeks later, Congress authorized the commission of a monument to venerate Montgomery and stipulated that Benjamin Franklin was to procure the monument in France. Franklin chose the French sculptor Jean-Jacques Caffieri to design the monument.

FIGURE 5.5. Preliminary sketch for the *Libertas Americana* medal (1782), by Augustin Dupre, with the infant Hercules sitting on a shield. This design was conceived of by Benjamin Franklin. *(American Philosophical Society.)*

FIGURE 5.6. Monument in honor of General Montgomery, by Jean-Jacques Caffieri. Herculean symbols are a prominent feature of the first US monument, which was kept in storage until it was shipped from France and installed at St. Paul's Chapel in Manhattan in 1787. *(Leah Reddy photographer / Trinity Wall Street.)*

With a strong interest in Hercules in particular and American symbols in general, Franklin clearly influenced Caffieri's design (figure 5.6). Prominent on the monument is a Herculean club bearing a ribbon on which is inscribed the word *libertas*.[108] The ribbon and sash are examples of Milky Way symbolism (see Chapter 8).

The Milky Way in Mythology

The Milky Way was a prominent component of Greek and Roman mythology. The term "Milky Way" refers to the broad band or arc of light visible in the night sky emanating from the Milky Way galaxy (figure 5.7). For the Greeks and Romans, the Milky Way stretched from horizon to horizon—a band of innumerable stars. When the infant Heracles woke Hera, she angrily pushed him away, and her milk sprayed across the heavens to become the Milky Way. Milk has traditionally been regarded as both the elixir of life and a source of heavenly enjoyment. Because of milk's association with newborn children, the Milky Way has been used for thousands of years as a symbol of birth and rebirth—of nations as well as people.[109]

FIGURE 5.7. *Within Reach* (2013), by Mike Salway. *(© Mike Salway.)*

Marcus Tullius Cicero, a Roman politician and orator, believed that the Milky Way encircled the earth; he referred to it as the *galaxias kyklos,* or "milky circle."[110] In *The Dream of Scipio*, Cicero discusses the Milky Way's significance as a symbol and how it is related to another symbol—a sash. Scipio is an adopted grandson of Scipio Africanus Major, a well-known Roman general. In young Scipio's dream, his grandfather appears before him and describes the heavenly abode known as the Milky Way, to which the great and honorable on earth are admitted after death. In an illustration of this dream, an anonymous fourteenth-century artist uses a sash of stars to signify the Milky Way (figure 5.8).[111]

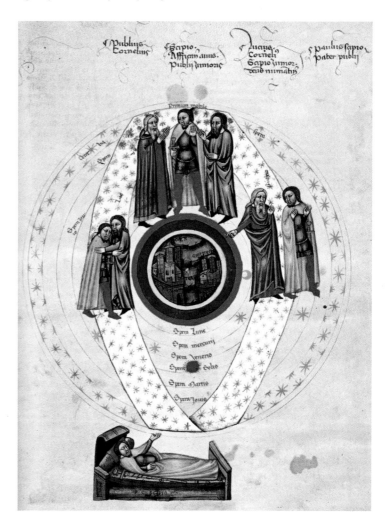

FIGURE 5.8. Scipio being shown the Milky Way by his father and grandfather (1383). *(The Bodleian Libraries, The University of Oxford, MS. Canon.Class. Lat.257, fol. 1v.)*

The appearance of the Milky Way was a subject of debate for hundreds of years. Aristotle believed that the Milky Way was a great circle around the earth. Marcus Manilus, a Latin poet and author of *Astronomica*, envisioned the arrangement of the Milky Way in the night sky as a *stellatus balteus,* that is, a zone or belt of stars. Five hundred years later, Ptolemy noted in the *Almagest* that the Milky Way is not strictly speaking a circle or a belt because it varies in width, color, and density and is bifurcated in one section.[112]

In a more poetic manner, Macrobius, a fifth-century writer, referred to the Milky Way as two sides of a band that form a sash or ribbon with stars. Soon after, the Bishop of Seville described the Milky Way as

> the bright circle (*de candido circulo*). The Milky Circle (*lacteus circulus*, i.e., the Milky Way) is the road seen in the sphere of the sky, named for its brightness (candor), because it is white. Some people say that this road is where the sun makes its circuit, and that it shines from the splendor of the sun's transit.[113]

It was generally agreed that the Milky Way was a path or a road for dead warriors to follow as they climbed into the heavens—Manilius describes the Milky Way as "the abode of the souls of heroes":

> That from the snow-white breast of heaven's queen there flowed a stream of milk which left its colour upon the skies; wherefore it is called the Milky Way, and the name derives from its actual origin. Or is it that a greater host of stars has woven its fires in a dense circlet and glows with concentrated light, and that the ring shines the more radiantly for the massing of its brightness? Perhaps the souls of heroes, outstanding men deemed worthy of heaven, freed from the body and released from the globe of Earth, pass hither and, dwelling in a heaven that is their own, live the infinite years of paradise and enjoy celestial bliss. If so, here we honour the line of Aeacus (whose sons were Peleus and Telamon, fathers respectively of Achilles and Ajax), here the sons of Atreus, and warlike Diomedes: the man of Ithaca, too,

FIGURE 5.9. Dante and Beatrice on a journey through the heavens that would culminate in paradise; from *Divina Commedia* (1544), by Dante Alighieri. *(The Newberry Library, Wing Folio ZP 535.P283.)*

who by the triumphs on land and sea was nature's conqueror; the Pylian, renowned for a long life of triple span, and the other Greek chiefs who fought at Troy (Virgil's Aeneas) etc. There is the gods' abode, and here is theirs, who peers of the gods in excellence, attain to the nearest heights.[114]

Early Christians believed that the Milky Way represented the path pilgrims took in the heavens heading toward God. There was thus a common belief throughout the centuries that the Milky Way is a bridge between the known world (the terrestrial) and the divine

world. As a result, depictions of the Milky Way are often reminiscent of Dante's image of an arduous upward climb to heaven, culminating in paradise (figure 5.9).[115]

In Milky Way symbolism, the stars that represent the Milky Way are arranged in a circle or in rows.[116] Rows of stars appear on early American flags (figures 5.10 and 5.11).

**PHASE 4:
MORE CONSTELLATIONS**

Milky Way

Circle of thirteen stars

Milky Way

Thirteen stars in five rows

FIGURE 5.11. Aristotle describes the Milky Way as a great circle around the earth; the Milky Way can also be represented as a band of stars and a ribbon or sash of stars arranged in rows.[116]

FIGURE 5.10. The Milky Way motif of stars arranged in rows. *(Courtesy Thomas A. Moeller.)*

PART 3

Heraldry

Cosmic Shields

A SHIELD IS A broad piece of durable material—often made of leather, wood, or metal—used as protection against heavy blows or missiles. Early shields were designed to identify the bearer, to serve as a type of insignia or rank, to identify one's country, to avert evil influence, to avoid bad luck, or to instill fear in the enemy. The symbols on a shield provide a wealth of information about both the owner and his culture. Many symbols regarded today as uniquely American—eagles, stars, crescents, wreaths—were employed by ancient Greeks and Romans on their shields.[117]

For example, an eagle appears in the boss (center) of the Roman shield in figure 6.1. The panel with the bull features a crescent (moon) and a constellation of stars. The bull was a badge for the eighth legion (Augusta). The stippling reveals that the owner was Junius Dubitatus, who served in the company or century of Julius Magnus in the army.[118] The date of the shield can be determined based on the fact that a detachment of Dubitatus's unit was sent to Britain during Hadrian's campaign (AD 122).

OPPOSITE: FIGURE 6.1. A Roman shield from the Imperial period (27 BC–AD 268) identifies the shield's owner. *(Reproduced by permission of the Huntington Library, San Marino, California.)*

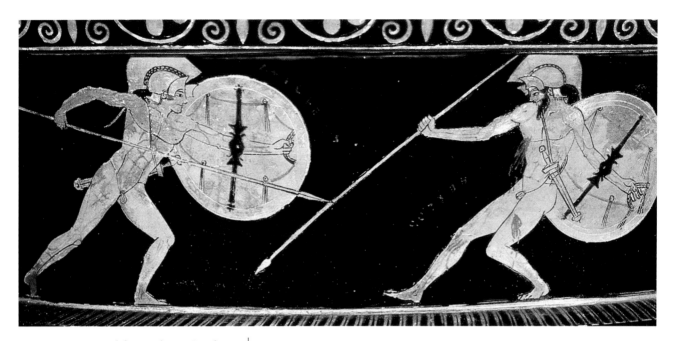

FIGURE 6.2. Detail from a large Greek bowl used for mixing wine (circa 490 BC) that was found in Italy and depicts the duel between Achilles (left) and Hector. *(© The Trustees of the British Museum. Pottery: red figured volute crater; The Berlin Painter; Reg. No. 1848,0801.1; Image 00094089001.)*

Some of the greatest poems, including ones by Homer and Virgil, feature cosmic shields. The word *cosmic* is derived from the Greek word *kosmos,* which refers to a universe that includes the earth, the sea, and the sky, encompassing by day the sun, clouds, and rainbows and by night the moon, stars, and planets.[119] Over the ages, and certainly by the late eighteenth century, cosmic took on a new and more modern meaning: of or relating to the universe, rather than to earth alone. In effect, the importance of the earth diminished over time, while the importance of the moon, stars, and planets increased.

This chapter focuses on the cosmic shields of Homer and Virgil, which profoundly influenced the US founders.

A Greek Shield

Figure 6.2 shows the inside of Achilles' and Hector's shields during their duel (*The Iliad*, Book 22). Homer describes the outside of Achilles' shield as comprising concentric bands (figure 6.3). At

FIGURE 6.3. A warrior brandishes a shield of stars in the center of Achilles' shield, detail from from Alexander Pope's *The Iliad of Homer* (1715–20). *(Reproduced by permission of the Huntington Library, San Marino, California. RB 148868 v5 p 1459.)*

the center of Achilles' shield is an elaborate scene of the cosmos—sky, sun, earth, moon, stars, and sea.[120] Homer further describes the core of the shield: "There he [Hephaestus/Vulcan] made the earth and there the sky and the sea and the inexhaustible blazing sun and the moon rounding full and there the constellations, all that crown the heavens." The center core of the shield is surrounded by a band that represents the zodiac. An outer band depicts two contrasting cities: one at peace, the other at war. The outermost band represents the "Ocean's River's mighty power."[121]

Although stars were widely employed on shields during the Homeric period, in all the works attributed to Homer, only three passages describe the ornamentation on shields.[122] Homer— in particular, Alexander Pope's translation of *The Iliad*—was widely read in eighteenth-century America, and the illustrations in Pope's edition influenced the symbols chosen to represent the new nation.

A Roman Shield

In *The Aeneid,* Venus gives Aeneas a cosmic shield modeled on the shield belonging to Achilles.[123] According to scholar Robert Fagles, "Achilles's shield has no names but those drawn from myth, no history; it is a picture of the world and human life." Aeneas's shield, on the other hand, depicts Rome's past and future and "is decorated with the deeds and names of those who through the ages have brought Rome to its position of world mastery."[124]

Aeneas marvels at and takes pleasure in the image on his shield as he lifts to his shoulder the depiction of the glory and destiny of his descendants and the founding of Rome. Virgil writes,

> the story of Italy,
> Rome in all her triumphs . . .
> all in order the generations of Ascanius' stock
> and all the wars they waged

Through Aeneas, Virgil informs readers about the source of this shield:

> My goddess mother (Venus) promised to send this sign
> if war were breaking out, and bring me armor
> down through the air, forged by Vulcan himself
> to speed me on in battle[125]

This scene appears in art and literature throughout the centuries (figures 6.4 and 6.5).

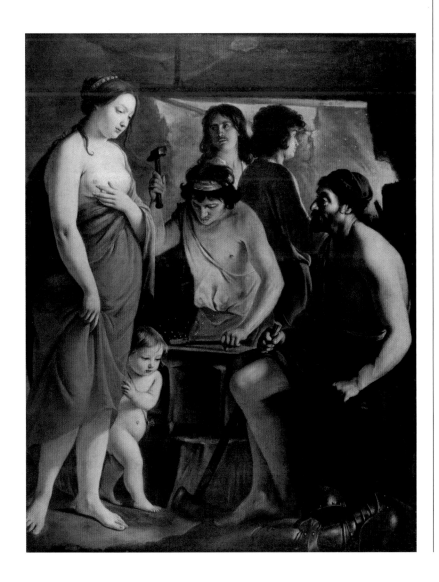

FIGURE 6.4. Vulcan, the blacksmith, constructing the shield for Aeneas in *Venus at the Forge of Vulcan* (1641), by Le Nain brothers. (© *Musee des Beaux-arts de la Ville de Reims, 922.21.*)

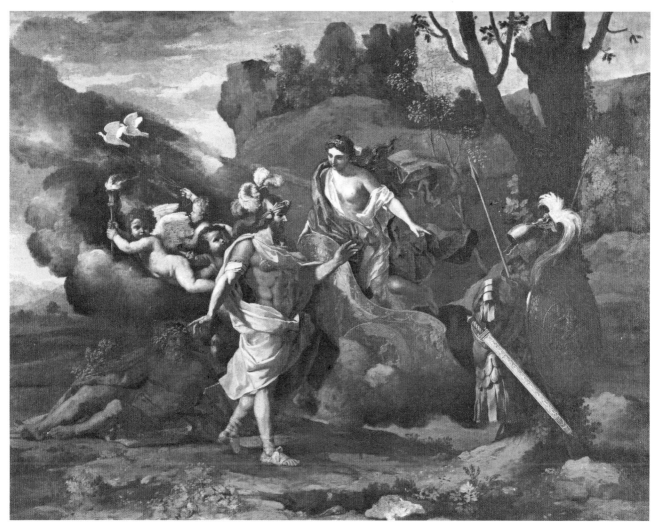

FIGURE 6.5. *Venus Presenting Arms to Aeneas* (1639), by Nicolas Poussin. *(Courtesy of the Art Gallery of Ontario, Toronto.)*

Cosmic Shields in Seventeenth-Century Heraldry

According to legend, Aeneas's shield dropped fully constructed from heaven; because the shield was a gift from Venus, the safety of the Roman Empire depended on its preservation. In modeling itself on Rome, the United States adopted Aeneas's shield as its own. Philip R. Hardie, author of *Virgil's* Aeneid: *Cosmos and Imperium,* argues that the *Aeneid* draws extensively on techniques and themes that can be broadly classified as cosmological.[126]

FIGURE 6.6. Coat of arms representing Pope Clement in pavement at St. Peter's Basilica, Portico. *(Courtesy Thomas Moeller.)*

To advance the premise that they were descendants of Aeneas, Roman Catholic clergy, as well as Roman nobility, regularly commissioned coats of arms (star shields).[127] For example, Gian Lorenzo Bernini's design of Pope Clement's pavement coat of arms included a star pattern (figure 6.6).[128] Artist Francesco Brizio designed coats of arms bearing stars for Italian nobility, including Cardinal Pompeo Arrigoni.[129] The Italian Altieri family claimed descent from Aeneas; and their arms appear on the flag of Aeneas's ship in Claude Lorrain's painting *The Landing of Aeneas at Palanteum*.[130]

Although there is universal agreement that Aeneas's shield is of cosmological origin, not all historians agree that Aeneas's shield is a "star shield." For example, heraldic scholar Sylvanus Morgan believed that the stars on Aeneas's shield represent fallen warriors and military heroes. He also posited that Aeneas's shield represented the Milky Way.[131] Morgan wrote that a shield of stars was so honorable that it was of "heavenly descent." He illustrated Aeneas's

FIGURE 6.7. Frontispiece of *Sphere of Gentry* (1661), by Sylvanus Morgan. Zodiac symbolism is revealed in the side of the armillary sphere. Note the Milky Way symbolism. *(Reproduced by permission of the Huntington Library, San Marino, California, RB 60512.)*

shield as a circular shield of stars representing the Milky Way (figure 6.7.). A shield also appears in Alciati's emblem book *Declaracion,* published by Lopez in Valencia in 1655,[132] a copy of which was in Benjamin Franklin's library.

Integrating Symbols

Steeped in the classics, America's founders hoped that their nascent nation would become the new Rome, so they appropriated Roman art, architecture, sculpture, and heraldry.

Two Philadelphians, Samuel Powel and John Morgan (Francis Hopkinson's brother-in-law), traveled to Italy in 1764 to study art and antiquities. Joined by Thomas Palmer and John Althrop, they studied under James Byrnes, a Scottish architect and art dealer who made his living teaching gentlemen about Roman art. The course began on May 21, 1764, and included visits to the Vatican

and Saint Peter's Basilica. Powel noted in his journal that he met Pope Clement X (an Altieri descendant).[133]

The class then studied the architecture, art, and sculptures of the large palaces: the Farnese, the Farnesina, the Rospigliosi, and the Borghese, as well as the Barberini (with a world-renowned ceiling fresco by Pietro da Cortona and its remarkable constellation of twelve stars arranged in a circle). Then the students visited a few of the smaller palaces in Rome, including the Altieri, Villa Albani, the Bolognietti, and the Corsini.[134] While at the Altieri palace, Powel noted in his journal, they viewed "A Landscape by Claude Lorrain esteemed his best in Rome." Likely the painting Powel referred to is *The Landing of Aeneas at Palanteum* (figure 5.1), which includes a blue ensign with twelve white stars arranged in a rectangle flying from the mast of Aeneas's ship.[135] In addition, the men surely noticed the Altieri coat of arms—a heraldic shield of stars—above the main entrance to the palace (figure 6.8). Both Powel and Morgan shipped works of art home, although it is not known what art they acquired in Rome. When Powel sailed for America from London aboard the *Pennsylvania Packet,* he was accompanied by Francis Hopkinson, who was traveling back to the colonies after visiting family in Great Britain.

Several prominent and wealthy Americans followed in the footsteps of Powel and Morgan over the next decade, including William Bingham, James Bowdoin, and Ralph Izard, as well as John Carroll, Arthur Middleton, and Arthur Lee, who a few years later would become US founders and contribute their knowledge of Roman symbolism to the search for symbols to represent the national identity.

FIGURE 6.8. Prince Altieri's coat of arms, detail from *Palazzo Altieri* (1665–66), by Giovanni Battista Falda. (*© Fundacio Instituto Amatller de Arte Hispanico. Archivo Mas.*)

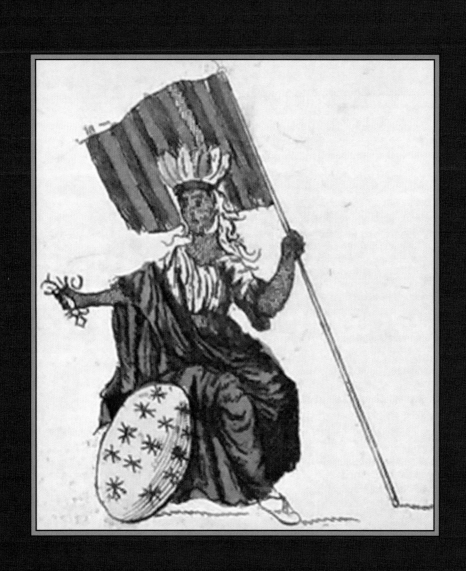

American Heraldry

THEORETICALLY, a national flag created using heraldic principles begins with a design on a shield. Once the armorial content of the nation's coat of arms has been determined, design of the national flag commences. Thus, one would assume that the shield (in the United States, this is the US coat of arms, or the Great Seal) is primary and the thirteen-star flag is secondary. One would further assume that the shield's heraldic content should enlighten the American people about the nation's flag and conversely the nation's flag should enlighten us about the heraldic content and design of the US coat of arms (1782). However, this is not true.[136]

This chapter is about an alternative shield known as a star shield that appears to have served as the heraldic basis for the first American flag. Although this unofficial and undocumented coat of arms was in common use for over a decade in the United States and Europe, its use as a national coat of arms eventually lost favor in the eyes of US founders. Instead of disappearing from the symbolic landscape, however, it was selected in 1790 to be the first seal of the US Supreme Court

A coat of arms—a heraldic composition comprising the distinctive device of a country or an individual—is used to authenticate important

OPPOSITE: Detail from *America to Her Mistaken Mother Rebus* (see figure 7.8).

or ceremonial documents.[137] In the eighteenth century, a metal block engraved with a coat of arms was often used to stamp, emboss, or mold a seal on paper or wax; when the seal appeared with an official's signature on a government document, the seal authenticated the signature.[138] The seal bearing the US coat of arms is impressed upon treaties and official documents issued by the president for the appointment of diplomatic ministers, cabinet officers, and foreign service officers.

Many different seals were employed during the American Revolution. However, because seals stamped in wax are fragile and liable to break or shatter, few revolutionary seals survive today. Furthermore, American seals are difficult to research because many libraries have not allocated sufficient resources to catalog them properly. Thus, the discussion here is based on engravings of seals on paper documents (currency, treaties, letters), not on seals that were stamped on wax.

The Great Seal

On June 20, 1782, Charles Thomson submitted a design to Congress for a coat of arms to represent the United States of America. Congress adopted the device—which became known as the Great Seal of the United States—that very day. Shortly thereafter, a die was cut and the seal was placed in service (figure 7.1).[139]

The American eagle is the central motif of the Great Seal. Over the eagle's head is a constellation of stars in a formation now known as a "grand luminary" design. This constellation denotes a new nation taking its place among sovereign powers. The shield on the eagle's breast represents the Union and the Congress. The eagle holds an olive branch in its dexter talon; in its sinister talon is a bundle of arrows.[140] The olive branch and arrows denote the power of peace and war that is vested in Congress. In the eagle's beak is a ribbon with the motto *e pluribus unum* ("out of many, one").

The thirteen vertical red and white stripes and a broad horizontal blue band across the top of the shield on the Great Seal are an outgrowth of the American flag that had been adopted years previously. Francis Hopkinson, considered the designer of the American flag, also created an early design for the Great Seal. Although

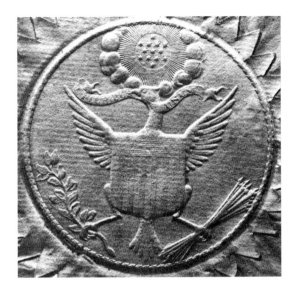

FIGURE 7.1. Impression of the die of the Great Seal of the United States, obverse (1782). *(National Archives and Records Administration.)*

a Congressional committee rejected Hopkinson's seal design, the committee retained a number of the motifs Hopkinson proposed.

Early American Star Shields

While the Great Seal of the United States is of paramount importance as a heraldic device and enlightens modern scholars about American symbols in 1782, it does not necessarily reflect an accurate representation of American symbols in use when the Flag Resolution was passed five years earlier. Early American flags are more likely based on star shields than on the heraldic principles evident in the national coat of arms.

Seventeenth-Century Seals

Star shields were used as seals in colonial America as early as the 1670s. For example, Rhode Islanders employed seals of stars for decades long before independence was declared. Between 1676 and 1683, the Town Council of Portsmouth used a seal of six eight-pointed stars arranged in a circle around a seventh star (figure 7.2).

The Town Council of Providence used two different star seals. A large star (or sun) with twelve wavy arms was used in 1676–77.

FIGURE 7.2. Seal used in Portsmouth, Rhode Island (1676–83). *(Courtesy the Rhode Island Historical Society, RHi X17 1375. p. 53.)*

FIGURE 7.3. Seal used by the Providence, Rhode Island, Town Council (seventeenth century). *(Courtesy Rhode Island Historical wSociety, R Hi X17 1375. p. 53.)*

Some years later, the Providence Town Council selected a seal of six six-pointed stars arranged in a circle around a twelve-pointed star (or sun) to represent the town (figure 7.3).[141]

Earliest Seal of the United Colonies

On September 5, 1774, twelve colonies sent delegates to the first Continental Congress in Philadelphia. Seven weeks later, Congress ordered the minutes of the meeting to be printed by William and Thomas Bradford at the London Coffee House in Philadelphia. The printed minutes include the seal shown in figure 7.4. When Georgia elected to join the union in 1775, this seal was redesigned so that

FIGURE 7.4. Seal on the title page of *Journal of the Proceedings of the Congress* (September 5, 1774) includes a fluted column held by twelve hands with a liberty cap resting on top. *(The Library Company of Philadelphia. September 5, 1774, Am 1774 Uni [1245.0.5] #2.)*

thirteen hands held a fluted column. This new seal may have been the first symbolic use of thirteen elements to represent the thirteen colonies,[142] and is evidence that Congress was experimenting with seal designs and heraldry as early as 1774.

Paper Currency

In 1769, Thomas Coram, an Englishman from Bristol who immigrated to Charleston, South Carolina, advertised his occupation as an engraver of coats of arms, ciphers, ornaments, and devices. He was a talented, self-taught artist who eagerly gleaned information from books, common practice, and the conversation of visiting artists. He served the revolutionary cause by engraving paper money, modeling his designs on the Roman cosmic shield from Virgil's Aeneas.[143]

The South Carolina General Assembly authorized two issues of paper currency, which had an emission date of February 8, 1779. A ninety-dollar bill engraved by Coram displays a star shield on the obverse side. A warrior wearing classical dress holds a shield with thirteen stars arranged in an oval constellation (figure 7.5). The motto is *Armis concurrite campo* ("With arms we run together into the field of battle"). The reverse displays Hercules wrestling the Nemean lion, a mythological figure.[144]

An eighty-dollar note with an emission date of February 8, 1779, also designed by Coram, depicts a warrior wearing classical dress holding a sword over a flaming altar with the motto *Constantia durissima vincit* ("The firmest constancy will conquer"). The reverse shows an oval shield with thirteen stars (figure 7.6). The interior of the shield has thirteen stripes. A liberty cap, two horns, olive branches, palm fronds, and two arrows or spears complement the artwork.[145]

Triumphal Arch

After the Definitive Treaty of Peace was signed by the United States and Great Britain in Paris on September 3, 1783, the Pennsylvania Assembly announced preparations for a public demonstration of joy on December 2 of that year. The focal point for the celebration would be the unveiling of a triumphal arch designed by Charles

FIGURE 7.5. Detail from South Carolina ninety-dollar note, obverse. *(Reproduced from the original held by the Department of Special Collections of the Hesburgh Libraries of the University of Notre Dame.)*

FIGURE 7.6. Detail from South Carolina eighty-dollar note, reverse. *(Reproduced from the original held by the Department of Special Collections of the Hesburgh Libraries of the University of Notre Dame.)*

Willson Peale. The arch was constructed in a style reminiscent of the ancient Greeks and Romans. Peale, who was also a flag designer and painter and studied art under Benjamin West, included a thirteen-star shield in the design. The arch would be lit with 1,100 lamps and embellished with illuminated paintings and inscriptions in homage to the Triumphal Arch in San Giovanni in Laterano, Italy, erected for the procession of Pope Clement X (figure 7.7).[146]

FIGURE 7.7. Triumphal Arch of Pope Clement X, erected in 1670. The globe (orb) above the arch displays the signs of the zodiac. (© *The Trustees of the British Museum. Reg. No. 1869,0410.723; Image 01346009001.*)

The Pennsylvania Assembly requested that the left side of the triumphal arch contain "A Sun, the Device of France—and Thirteen Stars, the Device of The United States, Caelo Sociati, Allied in the Heavens."[147] It is interesting to note that the Pennsylvania Assembly chose a thirteen-star shield to represent the United States rather than the nation's official Great Seal. Perhaps the Great Seal lacked the classical patina the assembly was seeking. There are no known illustrations of the completed arch, constructed of wood, paper, and canvas, because it was destroyed by fire the night of the event.

European Depictions of Star Shields

Although stars were often used as a motif in European heraldry, shields with numerous stars were rare. Yet, soon after the United States declared independence, Europeans began to use star shields to represent the thirteen United Colonies.

An English Engraving

In May 1778, less than a year after the American Flag Resolution was passed, English engraver Matthias Darly published an engraving of a Native American woman with a flag and a coat of arms. A shield with thirteen stars represents the thirteen colonies (figure 7.8).[148]

The Stars and Stripes in Holland

In a 1781 Dutch illustration (figure 7.9), a figure wears a gown with fleur-de-lis. She introduces an Indian princess (America) to an audience gathered around her. America wears a belt (balteus) bearing the word "Congress" and holds a thirteen-star American flag in her left hand. The stars on the flag are arranged in three rows (4-5-4).[149]

An English Copperplate Print

An English copperplate print (circa 1784–85) depicts George Washington driving a chariot of state drawn by two leopards (figure 7.10). Two Indian youths blowing trumpets precede Washington's

FIGURE 7.8. Detail from *America to Her Mistaken Mother Rebus* (May 11, 1778), by Matthias Darly. *(Courtesy, Winterthur Museum, 1954.0051.005.)*

FIGURE 7.9. An Indian princess holding an American flag in her left hand on the title page of *Le Politique Hollandais* (1781). *(Library of Congress. Prints and Photographic Division. DJi.P7 Pre 1801 Coll.)*

FIGURE 7.10. Detail from a copperplate print showing Minerva with a shield of stars. *(Courtesy Winterthur Museum; textile panel from the late eighteenth century 1960.0166.)*

chariot. One youth waves a red and white striped flag. The other waves a "Unite or Die" rattlesnake flag. Benjamin Franklin and Liberty are led by the goddess Minerva toward the Temple of Fame. Minerva bears a shield of stars with thirteen eight-pointed stars that represent the thirteen United Colonies. This copperplate print may have been created to educate observers about the origins of the American flag.[150]

Medals Engraved in Holland

LIBERA SOROR

On April 19, 1782, the Prince of Orange presented John Adams with a medal engraved by Dutch artist John George Holtzhev (figure 7.11). An Indian princess holds a shield of stars; the shield is identified as the *Libera Soror* ("free sister").[151] This constellation is identical to the canton of the first sovereign American flag. The text accompanying the medal provides insight into the meaning of the symbols:

> The sun shedding its rays on two maidens, one of whom, with breastplate and helmet, and personifying the States-General of the Netherlands, holds with her left hand a staff surmounted by a cap of Liberty over the head of her companion. The latter, an Indian queen (America), holds in her left hand a lance, a shield with thirteen stars (the thirteen original United States), and the end of a chain which binds a leopard (Great Britain), on whose head she rests her left foot. Their right hands, clasped, are extended over a fire burning on an antique altar ornamented with a caduceus and a cornucopia, the attributes of Mercury, god of commerce.[152]

TREATY OF AMITY AND COMMERCE

The Treaty of Amity and Commerce between the United States of America and the United Netherlands was concluded on October 8, 1782, and ratified on January 22, 1783. Soon after, a medal commemorating the treaty was presented to John Adams (figure 7.12).

FIGURE 7.11. A Dutch medal recognizing the United States of America (April 19, 1782). *(Reproduced by permission of the Huntington Library, San Marino, California. CJ 5805L8 v.2, Plate 12.)*

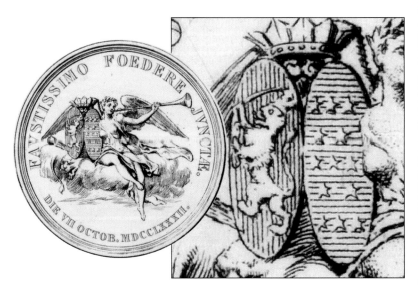

FIGURE 7.12. A Dutch medal commemmorating the Treaty of Amity and Commerce between the United States of America and the United Netherlands. The inscription translates as "United by a most auspicious alliance, October 7, 1782." *(Reproduced by permission of the Huntington Library, San Marino, California. CJ5805L8 v.2, plate 13.)*

The accompanying document describes the medal:

> Fame seated on the clouds is blowing a trumpet, held in her left hand; in her right she holds two shields: one bearing the arms of the United Netherlands, the other studded with thirteen stars (the thirteen original United States); above the two shields is a wreath, and beneath them are the lion's skin and the club of Hercules.[153]

First Seal of the Supreme Court of the United States

The US Supreme Court held its first session in New York City on February 4, 1790, with Chief Justice John Jay presiding. Its first order of business was to decide on a seal; that very day, the court ordered that "the Seal of the court shall be the Arms of the United States, engraved on a piece of steel of the size of a dollar with these words in the margin: 'The Seal of the Supreme Court of the United States.' "[154] The seal (figure 7.13) was completed and in use for the first time before May 1790; the name of the engraver and the exact date the seal was completed are unknown.

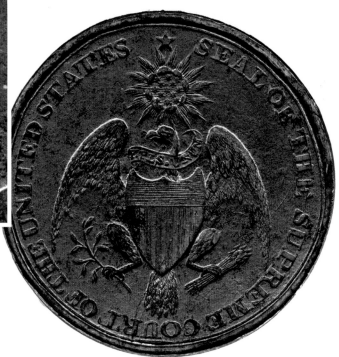

FIGURE 7.13. The first seal of the US Supreme Court (1790–1832). *(Collection of the Supreme Court of the United States.)*

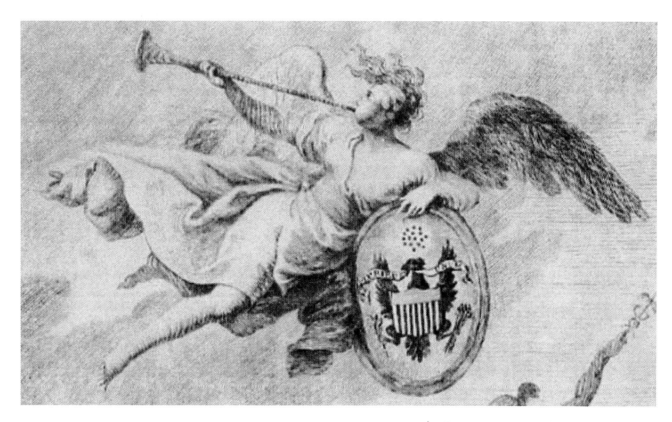

Once the US Supreme Court adopted the thirteen-star seal for its own use, the federal government discontinued using the star shield, substituting in its place the U.S. Great Seal (figure 7.14). The use of the thirteen-star American flag ended when Congress adopted a fifteen-star sovereign flag on May 1, 1795.

FIGURE 7.14. Detail from *Washington Giving the Laws to America* (circa 1800), showing the Great Seal. (*McAlpin Collection; Miriam and Ira D. Wallach Division of Arts, Prints, and Photographs; New York Public Library, Astor, Lenox, and Tilden Foundations.*)

PART 4

The Sovereign Flag:
A Composite

CHAPTER 8

Material Culture

ALTHOUGH THE Continental Congress did not leave a paper trail specifying how it created the American flag, another kind of record does exist in the form of material culture.

Material culture comprises human-made objects (artifacts) that inform us about the society in which the objects were created as well as the individuals who made or owned them. Artifacts are pieces of evidence that provide context to a modern understanding of a culture and its symbolism; they are primary data.[155]

> An artifact is something that happened in the past, but, unlike other historical events, it continues to exist in our own time. Artifacts constitute the only class of historical events that occurred in the past but survive into the present. They can be re-experienced; they are authentic, primary historical material available for first-hand study. Artifacts are historical evidence.
>
> Artifacts, like other historical events, do not just happen; they are the results of causes. There are reasons why an object comes into existence in a particular configuration, is decorated with particular motifs, is made of particular materials, and has a particular color and texture.[156]

OPPOSITE: *George Washington in the Uniform of a British Colonial Colonel* (see figure 8.8).

In *Art as Evidence*, Jules Prown identifies three causal factors of artifacts—craft, culture, and privacy:

> The first, craft, refers to tradition. Things are done or made in the way they were done or made previously. This is obviously true about artifacts whose artists and craftspeople are trained in art schools or apprenticeships, learn from [emblem books], and learn from other objects. The second type of causation, culture, refers to the mind of contemporary culture—prevailing attitudes, customs, or beliefs that condition the ways in which things are said, done, or made. It refers to the world in which both maker and consumer lived and which affected their values. People are a product of their time and place.[157]

The third causal factor, privacy, refers to the psychological composition of the person who made the object. Was the individual a conformist reflecting his or her contemporary society or an eccentric producing an original or idiosyncratic artifact?[158]

Ornamentation on objects speaks volumes about a culture's symbols. By studying artifacts, scholars can gain insight into the beliefs of the people who made, commissioned, purchased, or used these objects and, by extension, the beliefs of the society to which these individuals belonged.[159] This chapter presents examples of material culture that embody Revolutionary symbols that emerged from the renditions of Christianity, the classics, and mythology.

Clothing and Ornamentation

Headdresses

Because the head is such a prominent feature of the human body, many symbolic and ritual actions are embodied in ornamental head coverings. One type of headpiece is of particular significance to scholars of American history: the Phrygian cap.

Priests and inhabitants of Phrygia, a landmass in Asia Minor that is now part of Turkey, wore Phrygian caps.[160] Early Greek art depicts Phrygian caps (figure 8.1); Roman poets used the epithet "Phrygia" to identify a person of Trojan origin. In ancient Rome, emancipated

slaves received the *pileus libertatis* (liberty cap) as an emblem of manumission. Servants were permitted to wear liberty caps on the Saturnalia, a Roman holiday on which masters and servants reversed roles for a day.[161] Over the ages, the word *pileus* became a word for liberty itself, as in Livy's *servos ad pileum vocare,* "to call the slaves

FIGURE 8.1. A Bosporan queen wears a Phrygian star cap (930 AD), found in a Greek settlement in Turkey. (© *The State Hermitage Museum, St. Petersburg, Russia.*)

FIGURE 8.2. Seal of the Board of War and Ordnance (1778). *(Florida Center for Instructional Technology, College of Education, University of South Florida.)*

to liberty." A two-thousand-year-old Roman coin depicts the goddess of Liberty (slaves were freed in the goddess Feronia's temple; over time Feronia became identified with *Libertas*) holding a wand in one hand and offering a cap with the other, symbolizing the ritual by which slaves were released from bondage.[162]

The symbolism of Liberty (Libertas) became part of the iconography of the American Revolution. Images of Liberty with a *pileus libertatis* appear on the Philadelphia Light Horse flag (1775) and the first US Seal design by Pierre Du Simitiere (1776).[163] A soft red conical headpiece, often depicted with the top pulled down, appears on the first design of the state seal of Virginia (1776), the US Senate seal (1778), and the Board of War and Ordnance Seal (1778; figure 8.2).[164]

Sashes

A sash is a narrow woven band of silk or satin usually worn around the waist or thrown over the shoulder. Sashes were originally designed to carry wounded officers to medical assistance.[165] In the seventeenth-century British army, a sash was worn with a breastplate. By the eighteenth century, the sash had become a ceremonial mark of distinction, a badge that identified British officers on guard duty. With this new role, sashes were reduced in size, making them unsuitable for their original purpose.[166]

Civilians occasionally wear sashes on formal occasions as symbols of honor and prestige. The custom of wearing a sash for formal attire continues in diplomatic circles today. In Nicaragua, for example, it is customary for the president to wear a sash with a design similar to that of the Nicaraguan flag on official occasions.[167] Red sashes were worn on dress uniforms of seventeenth- and eighteenth-century British military field-grade officers and by American field-grade officers before the American Revolution.[168]

General Washington took command of the Continental Army in Boston in July 1775. Because there were no uniforms in the Continental Army, colored sashes were used to distinguish general officers, their aides, and brigade majors:

The Commander in Chief wore a light blue ribbon, the major and brigadier generals a pink ribbon and the aides-de-camp and

brigade majors a green ribbon. Towards the end of the same month it was thought proper to further distinguish the major generals from the brigadiers by changing the color of the major generals' ribbon to purple. These ribbons were described by one of the Brunswickers [English soldiers] captured at Saratoga in October 1777 as being worn by the American general officers "like bands of orders over their vests."[169]

According to general orders of July 14, 1775, the commander in chief was distinguished "by a light blue Ribband, [sic] wore across his breast, between his Coat and Waistcoat."[170] A 1776 painting by Charles Willson Peale depicts Washington wearing a blue sash (figure 8.3).[171]

FIGURE 8.3. *George Washington* (1776), by Charles Willson Peale. Washington is wearing a blue military sash and gold-washed epaulettes. *(Courtesy Mount Vernon Ladies' Association. CT-6441.)*

An inventory of Washington's belongings in 1799 revealed that he owned one blue sash.[172] A postrevolutionary painting of him as a Mason depicts him wearing a sash (figure 8.4).[173] Although no one knows when sashes became a part of Masonic symbolism

FIGURE 8.4. *George Washington* (1794), by William Joseph Williams. Washington is wearing a blue sash, the Past Master's jewel, and an apron. *(Collection of Scottish Rite Masonic Museum and Library, Lexington, Massachusetts; gift of Dr. William L. and Mary Guyton Collection. 86.61.123a.)*

in the United States, it is known that children of Virginia Masons were wearing ceremonial blue sashes as early as 1783.[174]

Flag scholar Schuyler Hamilton attributes Washington's blue sash military symbolism to the Covenanters, a group of Scots pledged to preserve Presbyterianism who subscribed to various bonds or covenants for the security and advancement of their cause.[175] The Covenanters wore blue sashes in opposition to royalty, who wore scarlet sashes. Blue represented egalitarianism, a social philosophy advocating the removal of inequalities among men. The color blue also represented the Whig political party.[176] According to biographer Carol Cadou:

> In military as well as civilian attire, George Washington outfitted himself in a manner that spoke of his rank, political sentiments, and ambition. In 1774 a body of Virginia gentlemen organized themselves into the Fairfax Independent Company and elected George Washington commanding field officer. He acquired a full set of regimentals in the chosen dress of the new corps—"a regular Uniform of Blue, turn'd up with Buff; with plain yellow metal Buttons, Buff Waist Coat & Breeches, & white stockings." The company's selection of blue and buff was symbolic. They were the colors of the English Whig party with whom American colonists felt themselves aligned against the ruling Tory party in power. Washington's blue and buff regimentals were sewn by his indentured tailor, Andrew Judge, and accented by his purchase of "an Officer's sash," gorget and epaulettes.[177]

FIGURE 8.5. Rosette stars from George Washington's uniform. *(The Pierpont Morgan Library, New York. MA 6029. Gift of Mrs. Schuyler, 1924.)*

George Washington discontinued wearing a blue sash on June 18, 1780, replacing it with two or three small star-shaped rosettes on two shoulder epaulettes; henceforth, this insignia denoted the rank of commander in chief. Several paintings show Washington wearing five-pointed stars (traditionally French) or six-pointed stars (traditionally British) on his epaulettes.[178] Two of the six-pointed stars Washington wore survive at the Pierpont Morgan Library in New York (figure 8.5).

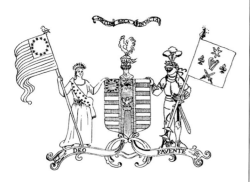

FIGURE 8.6. William Barton's first proposal for the Great Seal (1782). *(Department of the Army, The Institute of Heraldry.)*

FIGURE 8.7. William Barton's second proposal for the Great Seal (1782). *(National Archives and Records Administration, Washington, DC.)*

In 1782, William Barton submitted proposals for the Great Seal of the United States to the Continental Congress. In Barton's first proposal, the figure of America wears a sash with thirteen silver stars representing the Milky Way (figure 8.6). Barton referred to this band (incorrectly) "as a blue Scarf and Fillet, glittering with Stars." He appeared to be unacquainted with the heraldry he was attempting to convey. The correct heraldic term for Barton's scarf is "sash."[179]

In Barton's second proposal (figure 8.7), he referred to the sash as a "Sky blue Scarf, charged with Stars as in the Arms, reaching across her Waist from her right Shoulder to her left Side." [180]

Gorgets

Engravings on eighteenth-century American gorgets provide a glimpse into America's evolving sense of stars as sovereign symbols. England's first settlement in America was in Jamestown, Virginia, in the spring of 1607.[181] After a few skirmishes with local Indians, Captain John Smith, Jamestown's first military commander, realized that European armor and tactics were inadequate for subduing Native Americans. European body armor in particular was a liability. Smith's modification of a few pieces of body armor and abandonment of others, reinforced by subsequent military commanders, resulted in the decline in the use of body armor in North America over the next century. The sole type of body armor that survived the Revolutionary War was a piece of throat armor known as a gorget.[182]

In the eighteenth century, gorgets were primarily worn for ceremonial purposes, often on clothes designed for grand social occasions, and they served as a sign of dominion and sovereignty. By 1768, British gorgets were engraved with the king's arms and the number of the regiment to which a soldier belonged. They were made of silver or gilt to match uniform buttons and were suspended around the neck by a ribbon. Gorgets were also worn as companion pieces to sashes. French officers in North America wore gilded copper gorgets.[183]

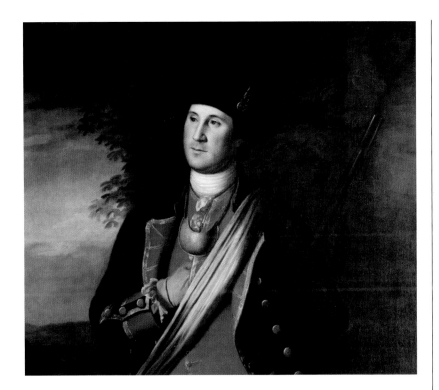

FIGURE 8.8. *George Washington in the Uniform of a British Colonial Colonel* (1772), by Charles Willson Peale. *(Courtesy Washington and Lee University.)*

The US Continental Army never officially adopted the gorget, yet it was a distinctive insignia worn by officers with field-grade status (majors, lieutenant colonels, colonels) during the Seven Years' War (1756–63) as well as during the American Revolution. Gorgets often bore arms of sovereign authorities—known technically as arms of dominion and sovereignty—to identify an officer's armorial authority and jurisdiction. Three examples of American gorgets survive today that provide a history of revolutionary symbols.[184]

In Peale's 1772 painting *George Washington in the Uniform of a British Colonial Colonel* (figure 8.8), Washington is wearing a gorget that is now owned by the Massachusetts Historical Society. The gorget is engraved with the arms of the Dominion of Virginia; such engravings are referred to as "cotes," which is a corruption of "coat of arms."[185]

FIGURE 8.9. Colonel Pinckney's gorget. *(Courtesy Charleston Museum, Charleston, South Carolina.)*

A gorget with thirteen five-pointed stars of graduating sizes engraved in a crescent shape along with the words "COL. C.C. Pinckney 1776" on the front (figure 8.9) is displayed at the Charleston Museum in Charleston, South Carolina.[186] Charles Coteworth Pinckney was elected to the rank of colonel in a Charlestown regiment of militia on September 16, 1776.[187] Although this gorget appears to be an eighteenth-century artifact, the engraving on the gorget may have been added at a later (but unknown) date.

A statue of Minerva as the patroness of American liberty provides another example of an early American gorget. In 1791, Roman artist Giuseppe Ceracchi sculpted a terra-cotta version of Minerva wearing a gorget adorned with thirteen seven- and eight-pointed stars as well as a liberty cap (figure 8.10).[188] Minerva's gorget appears to be made of goatskin or possibly the skin of the giant Pallas, whom Athena killed and flayed. In ancient art, the Greek

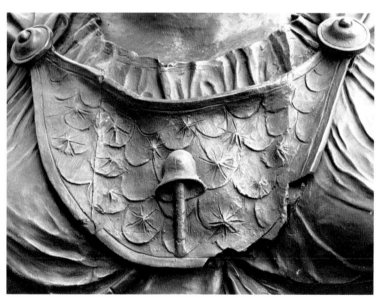

FIGURE 8.10. Detail from *Minerva as the Patroness of American Liberty* (1791), by Giuseppe Ceracchi. *(The Library Company of Philadelphia. Inv#37,#1 and Inv.#37, #3.)*

gods Zeus and Athena were often portrayed wearing an aegis like a breastplate.[189]

This sculpture was placed behind the chair of the speaker of the House of Representatives at Congress Hall in Philadelphia (now part of Independence National Historical Park.) After two years, the statue was moved to a small room containing a water closet. When Congress relocated to Washington in 1800, the 66-inch sculpture was given as a gift to the Library Company of Philadelphia, where it still resides.

Map Cartouches

A *cartouche* is the enclosed area within a map that may contain the title of the map, a legend, the artist's name, the engraver's name, and the date of publication (figure 8.11). *Cartouche* comes from the Italian word *cartoccio,* meaning an oval surrounding a coat of arms.[190]

Cartouches provide excellent data about the evolution of American flags. Some maps from the American Revolution include cartouches that contain images of American flags as well as the date of the map's publication. By comparing flags in cartouches, researchers can integrate symbolic information into a historic timeline.[191] They can also catch a glimpse of America's evolving sense of sovereignty.

Ecclesiastical Heraldry

In Christianity, *ecclesiastical* is used to identify the church; an *ecclesiastic* is a priest or preacher. Ecclesiastical heraldry has "long held a prominent place in the heraldry of America."[192] In colonial America, heraldic seals were derived from the Anglican Church and the Roman Catholic Church. Rather than covering a broad array of heraldic devices used by Christians, this discussion is focused on the ecclesiastical use of stars.

Although the occasional use of one or more stars as a motif on a heraldic shield was common in Europe in the sixteenth, seventeenth,

FIGURE 8.11. Four symbols on a cartouche from a Spanish map of the Delaware River: *clockwise from upper left,* a serpent (*ouroboros*); a sun constellation; a pine tree with the motto "An Appeal to Heaven"; and thirteen interlocking chain links with the motto "United We Stand." *(Museo Naval, Madrid. MN [Map] 5-A-5. 1780–1790.)*

and eighteenth centuries, shields of stars were rare. Star shields appear to have been reserved for deceased warriors or notable dignitaries in the Roman Catholic Church. The most notable star shields in ecclesiastical art were created by Francesco Brizio, a Renaissance master who engraved and painted heraldic designs, including coats of arms for popes and bishops at the Vatican, that were widely copied around the world. Shortly after US independence was declared, Europeans and Americans began to use a shield of stars to represent the United Colonies.

Paper Currency

Although historians cannot pinpoint the date when a circle of stars first appeared on an American flag, they can date precisely when the symbol first appeared on American paper currency. In 1778, Francis Hopkinson designed two examples of American paper currency with astronomical motifs. The forty-dollar note (figure 8.12) with an emission date of April 11, 1778, displays rays of sunlight from the all-seeing eye of providence (a sun symbol).[193] Above the eye is a nebula, a cloud-like patch in the sky. The sun is shining on a thirteen-star confederation of states. The word "Confederation" is inscribed on a ribbon underneath the circle of stars, while a flaming altar appears in the midst of the circle. The altar signifies the flame of liberty.

Hopkinson's design for a sixty-dollar note (figure 8.13) contains a zodiac band around the earth. The motto that accompanies this image reads, "God reigns, let the earth rejoice." The source of this motto is Psalm 97. This note has an emission date of September 26, 1778.[194]

The forty-dollar note employs both sun and star iconology. The sixty-dollar note, created five months later, uses zodiac (sun) iconology. The late flag scholar Howard Madaus believed that Hopkinson borrowed the circle of stars on the forty-dollar note directly from an American flag design he had executed a year before.[195] However, Hopkinson's circle of stars was likely inspired by the imagery of Jerusalem that appears in the Biblical book of

Revelation. The *Dictionary of Biblical Imagery* provides an expla-
nation of Jerusalem's astronomical symbolism:

> The author of Hebrews forbids Christians to give allegiance to
> the old city of Jerusalem but insists that they look to the new
> city by the same name (Hebrews 10:39; 12:22) "for here we do
> not have an enduring city, but we are looking for the city that is
> to come" (Hebrews 13: 14). The New Testament connects Chris-
> tian eschatological hopes to the New Jerusalem, a * heavenly
> city that will far transcend the glory of its earthly counterpart
> (Galatians 4: 26; Hebrews 12: 22).
>
> Finally, the apostle John portrayed the wonder of the new
> heaven and new earth by drawing attention to the royal city
> [Jerusalem] at its center (Revelation 21:22-24). In the New
> Jerusalem the people of God will enjoy unhindered worship
> under the great Davidic king, Jesus Christ (Revelation 21:3-4).
> The new city will be without a temple.[196]

FIGURE 8.12. Francis Hopkinson's forty-dollar note.
*(Reproduced from the original held by the Department of
Special Collections of the Hesburgh Libraries of the University
of Notre Dame. CC 1778 09 26 $40 front.)*

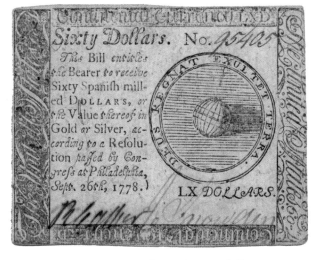

FIGURE 8.13. Francis Hopkinson's sixty-dollar note.
*(Reproduced from the original held by the Department
of Special Collections of the Hesburgh Libraries of
the University of Notre Dame. CC 1778 09 26 $60 front.)*

The Interpreter's Bible also discusses the astronomical symbolism of Jerusalem in Revelation:

> The heavenly city [New Jerusalem] quite naturally took on astral features. The sun and moon became the chief deities, while the twelve constellations of the zodiac symbolized lesser deities. The twelve portals through which the constellations were thought to pass become gates of the square city, with its sides facing the four winds of heaven. Also, it was thought that the Milky Way was a broad street or river through the city. The city itself had a certain cosmic significance in that it symbolized or came to be identified with the universe itself.[197]

Mary Hopkinson, mother of Francis Hopkinson, was a religious woman; her chief ambition was for her children to become good Christians. She encouraged her children to read the New Testament and was particularly devoted to Revelation.[198] As an adult, Francis Hopkinson was intrigued by the astronomical topics expressed in Revelation.[199] Using the image of a New Jerusalem as a guide to interpreting the forty-dollar bill, one can see that the eye of providence (or of God) furnishes the light for the advent of the new age, or the New Jerusalem. The light that lit up New Jerusalem was a street known as the Milky Way.

Because few words have been written about the origin, meaning, and symbolism of the earliest American flags, material culture provides primary evidence. The next chapter explores the heritage of the thirteen red and white stripes on the field of the American flag.

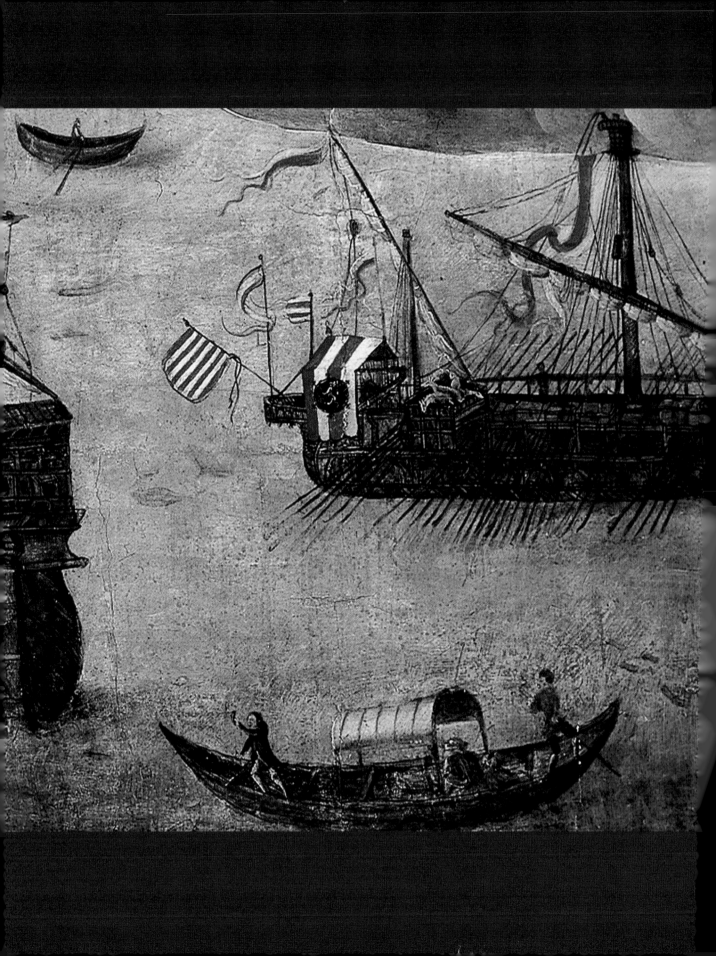

Red and White Stripes

W HEN STRIPES WERE officially conjoined with stars on the American flag on June 14, 1777, Congress gave the stripes precedence over the stars ("the flag of the United States [shall] be made of thirteen stripes, alternate red and white . . . the union [shall] be thirteen stars, white in a blue field"). Red and white striped flags were already in use on American battlefields at that point, so Congress's decision to give the place of honor to the stripes was logical. But the European heraldic tradition of giving the canton the place of honor on a flag soon prevailed—thus, the nickname "the stars and stripes."[200]

There is certainly something eye catching about the stripes on the American flag. "The stripe doesn't wait, doesn't stand still. It is in perpetual motion—that is why it has always fascinated artists: painters, photographers, filmmakers. [It] animates all it touches, [and] endlessly forges ahead."[201] But the mesmerizing motion of the stripes on a flag as it swirls about a flagpole is only a fleeting image. The enduring message of stripes lies in their symbolic imagery.

Although thirty-seven stars have been added to the canton of the American flag since 1777, the arrangement of stripes has changed only

OPPOSITE: Detail from *The Virgin of the Navigators* (see figure 9.10).

twice. Congress introduced a bill on December 26, 1793, adding two stars and two stripes to represent the two newly admitted states to the Union. The bill was signed and approved by President Washington on January 13, 1794, with the stipulation that beginning on May 1, 1795, the US flag would consist of fifteen stripes, alternate red and white, with a canton of fifteen white stars on a blue field.[202] In 1818, Congress voted to reduce the number of stripes to thirteen. Since then, there have been no changes to the field of the American flag.

The origins of American red and white striped flags are obscure. "It is singular that no mention of [the stripes'] official establishment can be found in the private diaries of the times, the official or private correspondence since made public of the prominent actors of the Revolution, the newspapers of the times, or the journals of the Provincial and Continental Congresses."[203] We do know, however, that red and white striped flags were in use before, during, and after the American Revolution.[204] In fact, Americans have flown striped flags for years knowing little about the stripes' heritage or traditions.

Understanding the use of a red and white striped flag as a symbol as opposed to its use as a signal presents a challenge. Symbols are often associated with heraldry, but the stripes on the American flag are not heraldic motifs. Thus, to gain insight into the stripes on the American flag, one must look beyond a heraldic explanation and explore the symbolism of Christian military banners and the use of red and white stripes as an emblem of victory.[205]

The Christian Cross as a Signifier of Victory

In the fourth century, the Christian cross looked different than it does today (figure 9.1 shows one example). Roman emperor Constantine the Great became a Christian and his standard became a symbol of victory after he experienced a vision on the day of the Battle of Milvian Bridge on the Tiber River in 312 AD. A cross appeared in the sky with the motto "By this symbol you will conquer."[206] According to Eusebius:

> It was like this: a long gilded spear with a transverse bar, like a cross. At the top of this same spear was affixed a wreath made of

FIGURE 9.1. A fourth-century Christian cross.

gold and precious stones. Within this was the sign of the saving
name: that is two letters signified the name "Christ" by means of
its initial characters, with the P [the Greek letter *rho*] in the mid-
dle [the X, the letter *chi*]. From this time on the emperor also used
to wear these same two letters on his helmet. From the crossbar
of the spear, a cloth was suspended: it was purple, covered with
precious stones joined together and interlaced with gold. . . . And
this banner affixed to the crossbar was square in shape.[207]

Constantine dreamt that Christ, holding that same cross,
admonished him to place the symbol on his standard and prom-
ised victory in return.[208] The next day, after Constantine defeated
his enemy, he decided to use the symbol as his standard. He added
three discs below the cross to represent himself and his two sons,
and the standard, which came to symbolize victory, became Con-
stantine's motif (figure 9.2).[209] By the fifth century, the three discs
had been deleted from the standard.

FIGURE 9.2. The imperial standard
of Roman emperor Constantine the
Great imprinted on a coin from a
Constantinople mint (327 AD). The
cross on the flag symbolizes victory
over death, a message employed by
European military flag designers for
more than a millennium. (© *The Trustees
of the British Museum. Reg.No.1890,0804.11;
Image 00164987001.*)

FIGURE 9.3. Drawing of a triangular red and white striped flag flown at the Battle of al-Qadisiyyah in Iran (636 AD). The flag was woven into an ancient tapestry depicting the event. *(Drawing by Barbara Moeller.)*

FIGURE 9.4. Drawing of a red and white striped textile wrapped around the base of a manger holding the infant Christ, based on an eighth-century silk serge fragment, possibly from Syria. *(Drawing by Barbara Moeller.)*

A cross that symbolized victory over death was a powerful symbol that was imitated and copied for millenniums and served as a theme for generations of military standard designers. The standard became known as a *labarum*.[210]

The Lineage of Red and White Stripes

In India, stripes are associated with the Hindu god Indra, warrior king of the heavens, god of war and storm.[211] Stripes are emblems of victory. Red and white stripes are also a symbol of triumph of good over evil and ignorance.[212] An early example of the use of stripes is found on a triangular red and white striped flag on a tapestry depicting the Battle of al-Qadisiyyah in Iran in 636 AD (figure 9.3).[213]

Christians in the Middle East adopted the use of stripes as a symbol (figure 9.4).[214] The red and white striped flag migrated to Europe during the Crusades (1096–1291 AD), when it was copied and adopted for use by European armies serving in the Middle East. After the Crusades, red and white stripes were common elements on flags and banners representing European Christian nations (figure 9.5).[215]

Red and white was also used in concert with the Christian cross. As the preeminent symbol of the Christian faith, the cross recalls the redemption of humans through the death of Christ. In England, a red cross on a white field appeared during the first Crusade; the cross became the symbol on the Cross of St. George flag after 1277 AD (figure 9.6).

According to legend, St. George was a third-century Christian Roman centurion of Syria in the service of a pagan emperor. Traveling through Libya, St. George came across the city of Silene. Silenians were living in terror of a dragon that had eaten their sheep and could be appeased only by the daily sacrifice of a maiden. Cleodolinda, the king's beautiful daughter, was awaiting her fate as the dragon's next meal. St. George rode up on his horse, made the sign of the cross, killed the dragon, and rescued the princess. Grateful Silenians converted to Christianity after this heroic display.

FIGURE 9.5. An illustration from *Lancelot du Lac* (circa 1300–15). The shield and the flag both have red and white stripes. *(The Pierpont Morgan Library, New York. MS M.806,f.158r.)*

During the Crusades, Crusaders wore a red flag with a white cross. St. George became a well-known saint; his association with military victory became even stronger after King Richard I noted that St. George appeared before him in a vision during the Third Crusade (1193) and promised him victory at Antioch.[216] By the end of the Crusades, the standard had come to represent England.

Banners that Signify Victory

A cross was inspirational to soldiers facing imminent conflict and was used as a symbol of a unit's common mission: victory. The symbol was also a comfort on the battlefield as soldiers faced death. Crosses and stripes appeared in depictions of battles and were intermingled on English flags (figures 9.7 and 9.8). Red and white stripes eventually acquired the meaning of victory even in the absence of a cross.[217] The cross appears on early English ensigns both with and without stripes, and by the reign of Queen Elizabeth I, a banner with a cross with stripes or simply stripes signified a war or military ensign.

Figure 9.6. Cross of St. George (circa 1277). *(W. G. Perrin,* British Flags *[Cambridge: Cambridge University Press, 1922], plate 1.)*

FIGURE 9.7. The Christian cross symbolizes victory over death; the striped flag below the banner signifies the triumph of good over evil. *(From Diego de Saavedra Fajardo* Idea de un Principe Politico Christiano *(1675) p161; reproduced by permission of The Huntington Library, San Marino, California. RB 377209 p161.)*

FIGURE 9.8. The striped flag signifies the triumph of good over evil; the cross on the banner symbolizes victory over death to a Christian soldier.[218] *(From Diego de Saavedra Fajardo* Idea de un Principe Politico Christiano *(1700) p189; reproduced by permission of The Huntington Library, San Marino, California. RB 113725 p189.)*

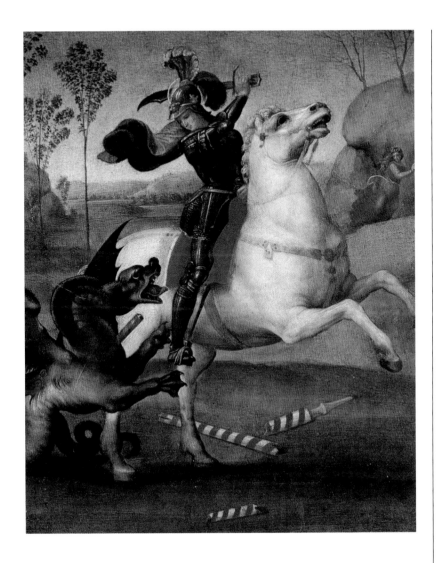

FIGURE 9.9. *St. George Fighting the Dragon* (circa 1505), by Raffaello Sanzio. *(The Louvre, Paris; © RMN-Grand Palais/Art Resource, NY.)*

An example of the use of red and white stripes to symbolize victory appears in Raphael's *Saint George and the Dragon* (figure 9.9), which depicts the forces of good and evil. Dragons are considered guardians of the underworld; the dragon in the painting represents the devil. St. George is a force for good. The broken red and white striped lance

is associated with chivalry and Christ's Passion. Like the spear it symbolizes masculine, phallic and earthly power. Its sacrificial link with the Grail derives from a legend that the spear that was used to pierce Christ's side after his death on the Cross was a

lance carried by a Roman centurion, Longinus, and that it was he who exclaimed, "Truly this man was the son of God." His lance, like that of the Greek Achilles, was credited with healing power. The broken lance is an attribute of St. George, and symbolizes the experienced soldier.[219]

Striped Banners in America

Red and white stripes may have migrated to a number of islands in the Gulf of Mexico in the Americas on the ships of Christopher Columbus. A painting of one of Columbus's ships (figure 9.10) documents the Spanish use of a red and white striped ensign.[220]

FIGURE 9.10. *The Virgin of the Navigators* (1505), by Alejo Fernandez. *(© Patrimonio Nacional.)*

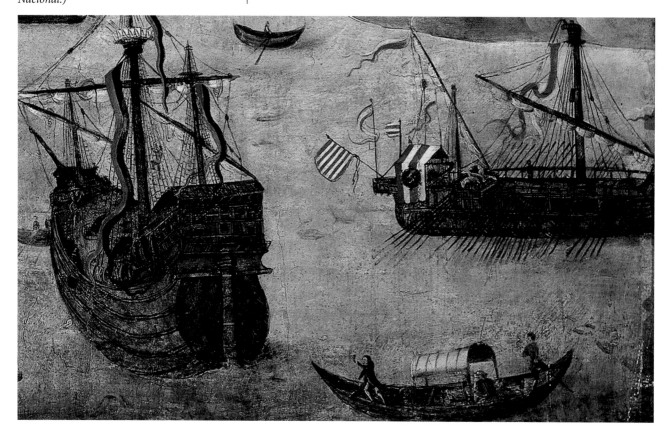

FIGURE 9.11. An American map cartouche (1680), by Vincenzo Coronelli. *(Reproduced by permission of The Huntington Library, San Marino, California. Map 105:330; the original map is in black and white.)*

Stripes were an American symbol well before the clamor for independence started: In 1680, Vincenzo Coronelli, an Italian cartographer and Franciscan friar, placed a cross on a striped shield on an American map cartouche (figure 9.11).[221]

American flag scholars routinely cite the East India Company flag (figure 9.12) as a source of red and white stripes on American flags, despite the fact that these ships rarely appeared in American waters.[222] In truth, the journey of stripes to the Americas is unclear; all historians know for sure is that stripes were in use in North America in the seventeenth century.

FIGURE 9.12. *An English East Indiaman, Bow View* (circa 1720), by Peter Monamy. *(National Maritime Museum, Greenwich, London. BHC1011.)*

The Signal Role of Striped Flags

By the eighteenth century, striped flags were the equivalent of a telephone call to notify troops that the enemy was nearby: an alarm that required an immediate armed response. Because red and white striped flags could be recognized from a far distance, they were ideal for rallying troops, signaling retreat, and declaring victory.[223]

On April 27, 1776, rebel forces used a red and white striped flag to announce the presence of the enemy on the Hudson River and to rally the troops.[224] A red and white flag was used in a naval engagement on the Hudson River on October 9, 1776 (figure 9.13).[225] Clearly, by the time of the Flag Resolution, the military use of red and white stripes was entrenched.

FIGURE 9.13. *Forcing the Hudson Passage* (1779), by Dominic Serres. *(Courtesy, Winterthur Museum. 1956.0563.)*

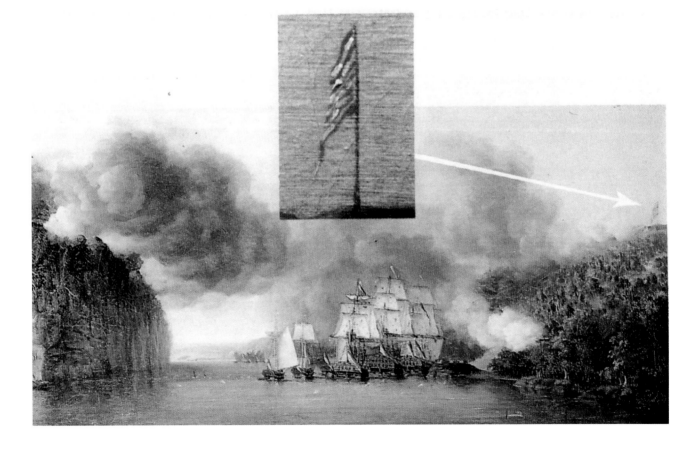

CHAPTER 10

Sovereign Birth

ALTHOUGH NUMEROUS iterations of thirteen sun-and-star American flags were in use during the revolution, the flag that became the sovereign flag made its first appearance not in 1776 or 1777, as countless historians claim,[226] but in 1783.

Congress ratified the preliminary articles of peace on April 15, 1783.[227] A week later, on April 23, Charles Thomson, secretary to the Continental Congress, identified the sovereign flag for the American people. He wrote, "The Printers in the several States are requested to insert the above Resolution [of June 14, 1777] in their respective newspapers, in order that the same may be generally known."[228]

Thomson thus provided US citizens with a written description of the sovereign American flag. Unfortunately, the American people would have to wait several months for an official image of the sovereign flag.[229]

Out of Many, One

By the end of the year, American and British map makers were publishing maps delineating the geographical boundaries of the

OPPOSITE: *Saint George* (mid-1470s), by Cosmé (Cosimo) Tura. England's patron saint bears a red, white and blue ribbon. *(Courtesy of the San Diego Museum of Art.)*

121

FIGURE 10.1. A sovereign American flag in *Bowles Universal Display* (1783), by Carington Bowles. *(Anne S. K. Brown Military Collection, Brown University Library.)*

United States. In publications sanctioned by their governments, these map makers included visual representations of the sovereign American flag in which thirteen white stars were arranged in a 3-2-3-2-3 constellation on a blue canton with thirteen red and white stripes (figure 10.1).[230]

At last, Americans had a flag that was recognized by other nations. The symbolism the founders selected to represent their culture emerged from star imagery derived from Greek and Roman cosmology, Christianity, the classics, foundation myths, and European art. A new constellation, forged out of liberty and freedom, joined other constellations representing older sovereign nations. United by their common cultural experiences as well as by the quest for freedom, the American people now had a symbol to which they could attach a national meaning (figure 10.2).

An Emotional Attachment Develops

National flags evoke strong feelings—positive or negative—and the American flag is no exception. But a nation's flag's ability to arouse intense feeling is not inherent in its design—emotive meanings are not woven into the fabric of a flag. Rather, feelings toward a national flag begin to grow and accumulate over time as the nation's citizens share experiences that bind them and their flag together into a common culture. More than two centuries after it became widely recognized as the premier symbol of the American people, the American flag is deeply loved and respected by US citizens at home and abroad. The founders borrowed symbolism from the past and made it come alive in a new cultural configuration that is the enduring symbol of a great nation.

FIGURE 10.2. An American sailor proudly displays his nation's thirteen-star American flag, on a map cartouche (1790) by Carington Bowles. *(The British Library Board. Maps 698 10 [104].)*

Portrait of a Designer

WHILE PONDERING the question of who designed the American flag, consider Mark Twain's comment: "I was gratified to be able to answer promptly, and I did. I said I didn't know." [231]

Francis Hopkinson submitted an invoice to Congress in 1780 for his services designing the American flag. When Congress denied payment, it acknowledged that Hopkinson was not the only contributor to the design of the American flag—the flag is the result of a collaboration among many people and many elements.

Francis Hopkinson

In 1767, Hopkinson traveled to England, where he met and dined with Thomas Newton, the bishop of Bristol. Newton gave Hopkinson a copy of his book *Dissertations on the Prophecies,* which was replete with symbols from Revelation as well as from the Roman Empire.[232] In a letter to his mother, Hopkinson wrote, "I dined a few days ago with Dr. Newton the Bishop of Bristol & Author of your favourite *Dissertations on the Prophecies*—I did not fail to thank

his Lordship for his valuable Work & let him know what a zealous Friend he had in you." Clearly, Mary Johnson Hopkinson was familiar with Newton's work and had shared her zeal with her son.[233]

A basic understanding of the Christian tradition as well as of Revelation's astronomical symbolism was helpful to Hopkinson as he wrestled with the design of the American flag, just as Reverend Samuel Sherwood struggled with Revelation's astronomical symbolism for his 1776 sermon "The Church's Flight into the Wilderness."

John Adams

Newton's work was also on the shelves of John Adams's library.[234] Adams was familiar with the classics as well as with Greek and Roman foundation myths, especially Virgil's *Aeneid* and Livy's *History of Rome*. He was well acquainted with mythological heroes who were known as nation builders, such as Hercules, Aeneas, and Minerva.

Benjamin Franklin

Benjamin Franklin was a leading proponent of sun symbolism and was a possible contributor to the early zodiac iconology on the American Flag canton. He appears to have been familiar with Milky Way iconology, as evidenced by his publication of *American Instructor*, a best seller that acquainted Americans with the myth of Hercules and the Milky Way.[235] Franklin's designs for American paper currency—one of which found its way onto a Revolutionary War flag—are notable examples of his impact. Franklin owned several emblem books, which he shared with other founders—his copy of Alciati's *Emblemata* is a likely source of the American star shield (see appendix A).[236]

George Washington

George Washington considered Virgil and Aeneas role models—so much so that he incorporated references to them into his home:

> As early as 1760, soon after his marriage to Martha Custis, Washington purchased for the centerpiece of his fireplace mantle,

a Groupe of Aeneas carrying his Father out of Troy, with four statues, *viz.* his Father Anchises, his wife Creusa and his son, Ascanius, neatly finisht and bronzed with copper.[237]

On Washington's fireplace, Aeneas supports his aging father and holds the hand of his son Ascanius. His wife Creusa stands next to him. As Aeneas and family depart from the ashes of Troy, Aeneas fixes his gaze on the prospects of a future Rome.

In *The American Aeneas,* John C. Shields writes that George Washington assumed not the role of Cato, which most moderns historican assert, but the role of Aeneas, Virgil's hero. In the same way that the Romans believed they were descendants of Aeneas, Americans consider themselves descendants of George Washington. Thus, according to Shields, Washington took on two roles: a personification of US character and a representation of the future promise of America.[238]

Benjamin West

A childhood friend of Francis Hopkinson, Benjamin West moved to England as an adult. His knowledge and understanding of the Bible, Roman and Greek history, and foundation myths was conveyed to his students—including John Singleton Copley, Charles Willson Peale, John Trumbull, and Francis Hopkinson.[239] West was also a good friend of Benjamin Franklin.

While in Europe, West had numerous contacts with Roman Catholic clergymen in Italy as well as with wealthy Englishmen and Americans sent abroad to learn about classical art and architecture and ecclesiastical heraldry. As historical painter to the court of King George III, West had access to the king's personal art collection. At that time, the monarch owned a pen and ink version of Claude Lorrain's *The Landing of Aeneas at Palanteum.*[240]

A rite of passage for wealthy Americans during colonial and revolutionary times was a "grand tour" of Europe. These tourists included Arthur Middleton, son of a prosperous plantation family and signer of the Declaration of Independence, who went to Rome in 1768; and Arthur Lee, who took a tour of Europe that included

Rome in 1774.[241] Portrait painter Charles Willson Peale trained with West from early 1767 to mid-1769.

West's knowledge of art in America and Rome, as well as his relationships with the educated men who followed him on subsequent pilgrimages to Rome, reinforced artistic and cultural ties between Rome and Philadelphia. The art and heraldry behind the initial design of the American flag and its accompanying shield of stars is a by-product of this cultural exchange. Although many candidates for the title of the designer of the American flag have been proposed over the years, the only certainty is that the flag that has symbolized the nation for more than 200 years is the product of a collaboration that is much greater than the sum of individual efforts.

APPENDIX A

Emblem Books

DESIGNERS OF EARLY American symbols routinely borrowed images from European emblem books and repurposed those images with a distinctly American meaning. The founders referred to Nicolas Verien's *Livre Curieux et Utile* (Paris, 1685), Andrea Alciati's *Emblemata* (Lyon, 1564), Diego Lopez's *Declaracion Magistral Sobre las Emblemas des Andres Alciato* (Valencia, 1655), and Diego de Saavedra Fajardo's, *Idea Principis—Christiano* (Amsterdam, 1659).[242] Figures A.1 and A.2 are examples of designs from two of these emblem books.

FIGURE A.1. A constellation, from *Livre Curieux et Utile*. (Princeton University Library. [ex] N7710 V47 1685.)

FIGURE A.2. A star shield, from *Declaracion Magistral Sobre las Emblemas des Andres Alciato. (Reproduced by permission of The Huntington Library, San Marino, California. PN 6349. A 4 1655f.)*

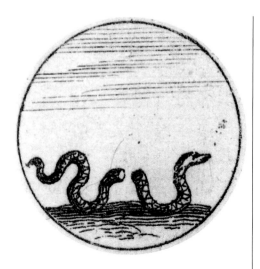

Figure A.3. *Livre Curieux et Utile* (1685) by Nicolas Verien. *(Princeton University Library. [Ex] N 7710 V47 1685.)*

One example of how emblems were reemployed is the rattlesnake image. A snake prototype appears in the 1685 edition of *Livre Curieux et Utile* (figure A.3).[243] In 1754, Franklin published an image of a snake cut into pieces; the snake represented the colonies (figure A.4). Underneath the image are the words "Join, or Die." This image, developed to reinforce the concept of colonial unity, was widely circulated in colonial print media for years. Because rattlesnakes are indigenous to North America, by the 1770s, the rattlesnake was a symbol of American independence and of unity.

Designers of American currency also relied on European emblems and Latin mottoes.[244] When the Continental Congress appointed Benjamin Franklin to a committee to design and oversee the printing of paper currency, Franklin provided ten devices with mottoes, seven of which were based on illustrations in emblem books in his library.[244]

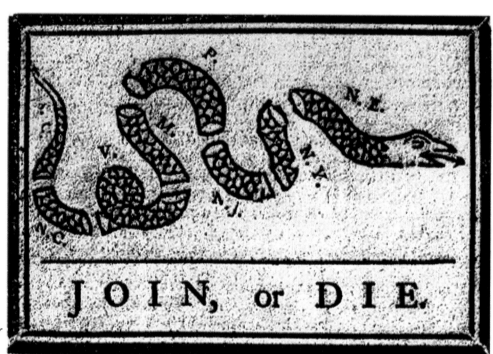

FIGURE A.4. *Join or Die*, (1754), by Benjamin Franklin. (Pennsylvania Gazette, *May 9, 1754; Newspaper Division, Library of Congress.)*

The other three devices were from original drawings. One of Franklin's original devices is known as the We Are One design (figures A.5. and A.6).[245] This drawing of a circle of interlocked circles features the phrase "We Are One" in the center. Franklin sought to symbolize colonial union by using the circle as a metaphor for eternity and by including the phrase "We Are One."

Because Franklin depicted each state as a circle, he recognized the authority of each individual government as an institution to be valued and perpetuated throughout all time. At the same time, by arranging the thirteen distinct circles to constitute a larger circle, he suggested that the authority of the transcendent government, the Congress, should also be valued and perpetuated throughout eternity.[246]

The chain of circles symbol was first printed on American paper currency on February 17, 1776 (figure A.7). Thereafter, the symbol

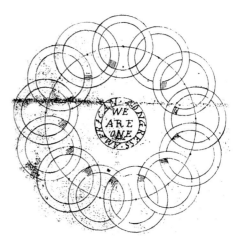

FIGURE A.5. Ink sketch of thirteen interlocked rings (undated), by Benjamin Franklin. (*American Philosophical Society.*)

FIGURE A.6. Two ink sketches of thirteen interlocked rings (undated), by Benjamin Franklin. (*American Philosophical Society.*)

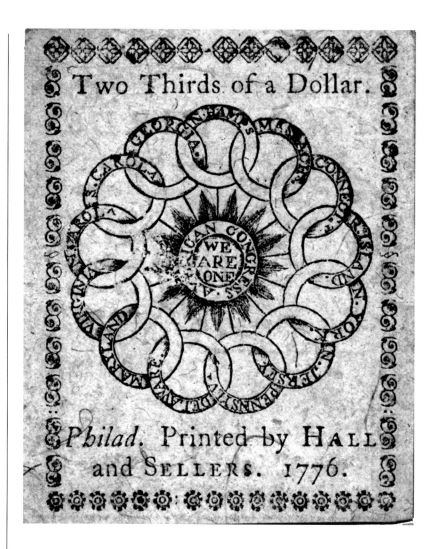

appeared on military flags, metal coins (figure A.8), state paper currency, newspaper mastheads, buttons, carpets, pitchers, bowls, and plates.

On July 8, 1777, a We Are One flag was found among captured American military equipage at Fort Ann, New York. The flag displays thirteen intertwined circles that are very similar to Franklin's device (figure A.9)[247]

Franklin's idea of using interlinked rings to designate distinct governments in relation to an overarching government may have been imagery evoked by the Iroquois. He knew that the Six Nations had a

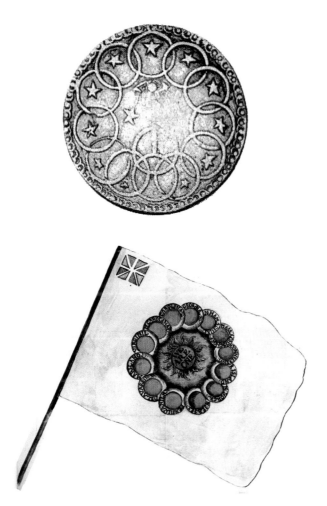

FIGURE A.8. American shilling with stars and rings (1783), by John Chalmers. *(R. S. Yeoman,* Guide Book of United States Coins. *Atlanta: Whitman Publishing Company, 2010.).*

FIGURE A.9. We Are One flag (1777), by Lt. Col. Christian Praetorius. *(Niedersachsisches Landesarchiv-Staatsarchiv Wolfenbuttel. WO-56500-M/13/Lo.)*

unified form of government, embodied in the image of a long house. He also knew that among the Iroquois, "brightening the chain" was a pervasive image for unity among the distinct governments.

Between 1736 and 1762, Franklin printed at least thirteen treaties made with the Indians, usually between Pennsylvania and the Iroquois confederacy, a factor that indicated Franklin's deepening familiarity with the Iroquois confederacy long before his earliest comments on colonial union. Most of these treaties used phrases such as "brighten the chain," "chain of friendship," "covenant chain," "chain of peace," and "chain of union," all of which symbolized the relationship between the parties to the specific treaty.[248]

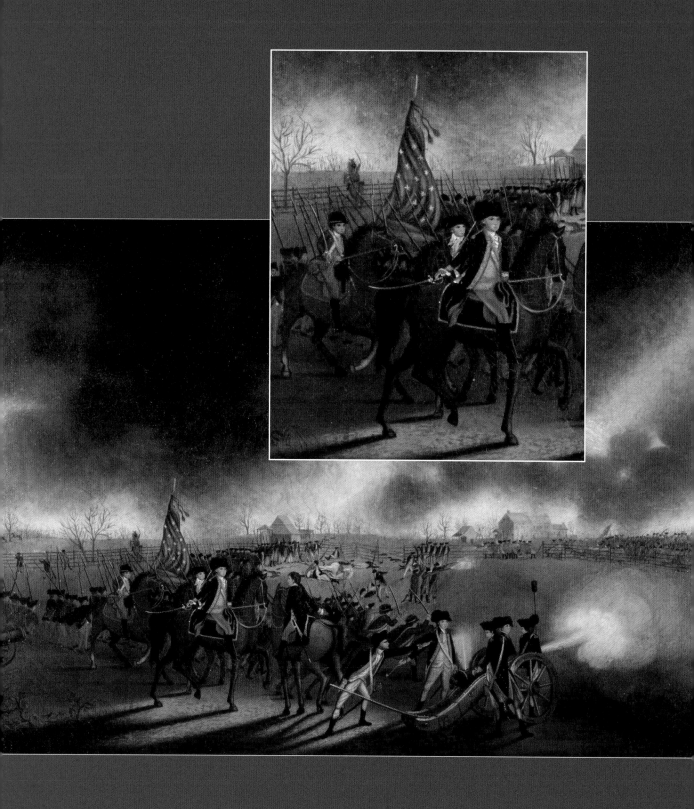

Two Milky Way Flag Designs

TWO LINEAGES are associated with the earliest US flag cantons: one derived from the sun and one derived from a constellation or galaxy of stars that represent the Milky Way. Early flags bore a sun or zodiac symbol, reminiscent of what Aristotle referred to as a small circle. Twelve stars were first employed to depict the sun or the zodiac; when a thirteenth star was added, the American "sun" transmuted into a symbol of stars that Congress redefined as a "new constellation."

Early American flag cantons also bore Milky Way symbolism. Although Aristotle referred to the Milky Way as a large circle, the Milky Way can also be depicted as a band—or rows—of stars. The Milky Way motif harkens back to imagery associated with Hercules (figure B.1), Plato's *Timaeus* and *Republic,* and Cicero's *The Dream of Scipio* (see figure 5.8).

James Peale's painting *The Battle of Princeton,* a scene from the seminal battle of 1776, shows the Milky Way arrangement of rows of stars on a flag in use before the Flag Resolution of June 14, 1777 (figure B.2). Military historian Donald Holst believes this flag was used as early as 1774 by General George Washington's Alexandria Light Dragoons, a unit in the Virginia militia.[250]

FIGURE B.1. Detail from a Tyrrhenian amphora (circa 570-560 BCE) showing Heracles, Nessus, and Hercules's wife Deianeira, who is wearing a robe decorated with stars. *(Museumslandschaft Hessen Kassel, Antikensammlung T385 detail.)*[249]

OPPOSITE: FIGURE B.2. *Battle of Princeton* (1782), by James Peale. *(Graphic Arts Collection. Department of Rare Books and Special Collections. Princeton University Library.)*

Endnotes

PREFACE

 i. Joan Breton Connelly, *The Parthenon Enigma* (New York: Knopf, 2014), ix.

 ii. Anthony S. Pitch, *The Burning of Washington: The British Invasion of 1814* (Annapolis: Naval Institute Press, 1998), 103.

 iii. Robert C. Alberts, *Benjamin West: A Biography* (Boston: Houghton-Mifflin, 1978), front flap.

 iv. David McCullough, *The American Spirit: Who Are We and What Do We Stand For* (New York: Simon & Schuster, 2017), 152.

CHAPTER 1

 1. Scot M. Guenter, *The American Flag, 1777–1924: Cultural Shifts from Creation to Codification* (Rutherford, NJ: Fairleigh Dickinson University Press, 1990), 167; Woden Teachout, *Capture the Flag: A Political History of American Patriotism* (New York: Perseus, 2009), 153; and Whitney Smith, ed., *Honor the Flag! The United States Flag Code Annotated and Indexed Incorporating August 1998 Changes* (Winchester, MA: Flag Research Center, 1998), 5.

 2. William Bray, ed., *The Diary of John Evelyn. Esq., F.R.S. from 1641 to 1705–6: With Memoir,* vol. 1 (London: Henry Colburn, 1857), 357; and Eugene Zieber, *Heraldry in America* (New York: Crown, 1984), 32.

 3. George Canby, *The Evolution of the American Flag* (Philadelphia: Ferris & Leach, 1909), 11.

4. Marc Leepson, *Flag: An American Biography* (New York: St. Martin's, 2005), 265.

5. *Webster's New Collegiate Dictionary*, 4th ed., s.v. "dove"; and George Ferguson, *Signs and Symbols in Christian Art* (London: Oxford University Press, 1961).

6. Charles D. Elder and Roger W. Cobb, *The Political Uses of Symbols* (New York: Longman, 1983), 29.

7. Leslie A. White, *The Science of Culture: A Study of Man and Civilization* (London: Forgotten Books, 2013), 24–25.

8. Raymond Firth, *Symbols Public and Private* (London: George Allen & Unwin, 1973), 427.

9. Elder and Cobb, *Political Uses of Symbols*, 29–30.

10. Ibid., 29, 31.

11. John J. McCusker, *Alfred: The First Continental Flagship 1775–1778*, Smithsonian Studies in History and Technology, no. 20 (Washington, DC: Smithsonian Institution Press, 1973).

12. Leepson, *Flag*, 15.

13. Ibid.

14. Howard M. Madaus and Whitney Smith, *The American Flag: Two Centuries of Concord and Conflict* (Santa Cruz, CA: VZ Publications, 2006), 10.

15. Leepson, *Flag*, 21; and Brendan McConville, *The King's Three Faces: The Rise and Fall of Royal America, 1688–1776* (Chapel Hill: University of North Carolina Press, 2006), 307–311.

16. Whitney Smith and Peter Orenski, *Long May It Wave! The National Flag of the United States, Past, Present, and Future* (Winchester, MA: Flag Research Center, 1998), 4.

17. Leepson, *Flag*, 21.

18. Ibid., unnumbered plate following 174.

19. John Ayto, *Dictionary of Word Origins* (New York: Arcade, 1993), 299.

20. Elizabeth Jewel and Frank Abate, eds., *The New Oxford American Dictionary*, c.v. "influence."

21. David Ovason, *The Secret Architecture of Our Nation's Capital* (London: Century Books, 1999), vii.

22. *Journals of the Continental Congress, 1774–1789*, ed. Worthington C. Ford et al. (Washington, DC: US Government Printing Office, 1904–37), 8: 463–465.

23. Samuel Johnson, *A Dictionary of the English Language*, 4th ed. (London: J. and P. Knapton et al., 1755), c.v. "constellation," 457.

24. Peter Whitfield, *Astrology: A History* (New York: Harry N. Abrams, 2001).

25. Franklin B. Dexter, *The Literary Diary of Ezra Stiles, D.D., L.L.D., President of Yale College*, vol. 2 (New York: C. Scribner's Sons, 1901), 181; and William R. Furlong and Byron McCandless, *So Proudly We Hail: The History of the*

United States Flag (Washington, DC: Smithsonian Institution Press, 1981), 101–102. According to Don Wilcox, curator of books at the William Clements Library, University of Michigan, Ann Arbor, the term *constellation* does not refer to stars arranged in any particular or specific grouping (e.g., a circle), but rather to a collection of stars (personal communication with the author, November 20, 2001). In *Dictionary of the English Language*, Johnson defines a constellation as "an assemblage of splendours, or excellencies" (see note 23, above). The idea that the United States was joining the older sovereign nations of the world while representing unique qualities arose from extensive reading of contemporary newspapers, Thomas Paine's works, and Thomas Jefferson's First Inaugural Address, as well as personal communication with architectural historian Pam Scott (May 5, 2007). For more on Thomas Paine, see Kevin Keim and Peter Keim, *A Grand Old Flag: A History of the United States through Its Flags* (New York: DK, 2007), 43.

26. James A. Garraty and Mark C. Carnes, eds., *American National Biography,* vol. 20 (New York: Oxford University Press, 1999), 772. Stiles likely obtained information about the Flag Resolution via parishioner William Whipple, a delegate to the Continental Congress who also served on the Marine Committee, the Secret Committee, and the Board of War. See also Dorothy M. Vaughan, *This Was a Man: A Biography of General William Whipple* (Lunenburg, VT: Stinehour Press, 1964).

27. Barbara B. Oberg, ed., *The Papers of Thomas Jefferson,* vol. 33, *17 February to 30 April, 1801* (Princeton: Princeton University Press, 2006), 148–152.

CHAPTER 2

28. Ellis Sandoz, ed., *Political Sermons of the American Founding Era (1730–1805)* (Indianapolis: Liberty Press, 1991), xii.

29. Ibid., v.

30. Ibid., 493–527.

31. Simon Price and Peter Thonemann, *The Birth of Classical Europe: A History from Troy to Augustine* (New York: Viking, 2010), book jacket.

32. Carl J. Richard, *The Founders and the Classics: Greece, Rome and the American Enlightenment* (Cambridge, MA: Harvard University Press, 1995), 1.

33. Ibid., 10, 50.

34. Ibid., 12.

35. Frank H. Sommer, "Emblem and Device: The Origin of the Great Seal of the United States," *Art Quarterly* 24, no. 1 (1961): 58; and "Heraldic badge," *Wikipedia*, accessed November 17, 2017, https://en.wikipedia.org/wiki/Heraldic_badge.

36. Alfred Znamierowski, *The World Encyclopedia of Flags: The Definitive Guide to International Flags, Banners, Standards and Ensigns* (London:

Hermes House, 2002), 14, 29; and Whitney Smith, *Flags through the Ages and Across the World* (New York: McGraw-Hill, 1975), 13.

37. J. E. Cirlot, *Dictionary of Symbols* (New York: Philosophical Library, 2002), 342. See also Percy Preston, *A Dictionary of Pictorial Subjects from Classical Literature: A Guide to Their Identification in Works of Art* (New York: Charles Scribner's Sons, 1983). In the *Iliad*, all thunderbolts come from Zeus unless otherwise indicated; Preston, *Dictionary of Pictorial Subjects*. See Michael Ferber, *A Dictionary of Literary Symbols* (Cambridge: Cambridge University Press, 2007), 116.

38. Robert Fagles, trans., *Virgil: The Aeneid* (New York: Penguin, 2006), 13.

39. John C. Shields, *The American Aeneas: Classical Origins of the American Self* (Knoxville: University of Tennessee Press, 2001), xxv.

40. Henry W. Moeller, *Shattering an American Myth: Unfurling the History of the Stars and Stripes,* 2nd ed. (Mattituck, NY: Amereon, 1995). For a discussion of the early Swedish coat of arms, see p. 261.

41. Carl G. Liungman, *A Dictionary of Symbols* (Malmo, Sweden: Merkur International, 1974).

42. Richard Barber, *King Arthur: Hero and Legend* (Woodbridge, England: Boydell, 2004). See also Rodney Castleden, *King Arthur: The Truth Behind the Legend* (New York: Routledge, 1999), 5.

43. Acton Griscom, *The Historia Regum Britanniae of Geoffrey of Monmouth* (London: Longman's, Green, and Co., 1929), 438; Geoffrey of Monmouth, in *Histories of the Kings of Britain* (London: J. M. Dent and Sons, 1944), 159, calls the shield "Priwen" and states that its inner side was painted with the image of Mary, mother of God.

44. Guillaume Du Choul, *Veterum Romanorum Religio: Catrametatio, Disciplina Militaris ut & Balneae* (Amsterdam: Janssonio-Waesbergios, 1686), 43. See Monica Dodds and Bill Dodds, *Encyclopedia of Mary* (Huntington, IN: Our Sunday Visitor, 2007). Individual stars conveyed the status of a god in numerous cultures in antiquity. See also Udo Becker, *Continuum Encyclopedia of Symbols* (New York: Continuum, 1994), 281. Mary is also linked to a constellation, as discussed in chapter 4 of this book.

45. Anna Brownell Jameson, *Legends of the Madonna: As Represented in the Fine Arts* (New York: Charles L. Bowman, 1890), xlvii.

CHAPTER 3

46. Marcia Bartusiak, *Archives of the Universe: A Treasury of Astronomy's Historic Works of Discovery* (New York: Pantheon, 2004), 90–98.

47. Brendan McConville, *The King's Three Faces: The Rise and Fall of Royal America, 1688–1776* (Chapel Hill: University of North Carolina Press, 2006), 205. George I was the first British monarch to be identified with the sun; King Louis XIV and King Louis XV were known as "sun kings."

48. Ibid., 203, 206, 207.

49. Ibid., 306–311, 313.

50. Ferber, *Dictionary of Literary Symbols,* 209. After the United States and France became allies in 1778, the American preference for sun iconology likely made the French government uncomfortable. It was at this point that the founders began to contemplate abandoning the use of sun iconology.

51. The glory (sun) altarpiece at St. Paul's Chapel, New York, designed by Pierre Charles L'Enfant, is an example of early American sun symbolism. The original design is attributed to Gian Lorenzo Bernini and is from a Roman Catholic Church in Paris or Rome. See Michael Paul Driskel, "By the Light of Providence: The Glory Altarpiece at St. Paul's Chapel, New York City," *Art Bulletin 89*, no. 4 (December 2007): 715–737.

52. Eric P. Newman, *The Early Paper Money of America* (Iola, WI: Kraus, 1997), 245.

53. Page Talbott, ed., *Benjamin Franklin: In Search of a Better World* (New Haven, CT: Yale University Press, 2005), 30.

54. Lester C. Olson, *Benjamin Franklin's Vision of American Community: A Study in Rhetorical Community* (Columbia: University of South Carolina Press, 2004), 112.

55. Ibid., 113.

56. Charles E. Peterson, *The Rules of Work of the Carpenter's Company of the City and County of Philadelphia (1786)* (Princeton: Pyne Press, 1971); and Pamela Scott, *Temple of Liberty: Building the Capitol for a New Nation* (New York: Oxford University Press, 1995).

57. The chair was intended to serve as the speaker's chair in the Pennsylvania Assembly. A liberty cap and rising sun motif are carved into its crest rail. Robert Giannini of the National Park Service commented that the chair was ordered by the Pennsylvania Assembly in 1779 (personal communication with the author, April 1, 2002). The chair was taken to Lancaster in 1799 and to Harrisburg in 1812. In 1867, it was returned to Philadelphia and placed in the Assembly Room of Independence Hall, where it remains.

58. Olson, *Benjamin Franklin's Vision,* 127–128.

59. William Ellery, "Diary of the Hon. William Ellery of Rhode Island, June 28–July 23, 1778," *Pennsylvania Magazine of History and Biography* 11, no. 4 (1887): 476.

60. Jonathan Barnes, ed., *The Complete Works of Aristotle: The Revised Oxford Translation,* vol. 1 (Princeton: Princeton University Press, 1984), 564.

61. Fernando Altieri, *Dizionario Italiano ed Inglese* [Dictionary of Italian and English] (London: William and John Innys, 1726–27). The Library Company of Philadelphia owns a copy of volume 1, the front flyleaf of which

was inscribed by Joseph Breitnall or Benjamin Franklin. The Library Company owns another copy with the signature of Benjamin Rush.

62. Helene E. Roberts, ed., *Encyclopedia of Comparative Iconography: Themes Depicted in Works of Art,* vol. 2 (Chicago: Fitzroy Dearborn, 1998), 957–958. In art, the zodiac takes a number of forms: globe, planisphere, band, circle, ring—and an arch. In the eighteenth century, zodiac signs or stars were often inserted into arches supported by columns. For example, in *United States* magazine (January 1779), Francis Bailey depicts thirteen states on an arch, each represented by one star. The arch is the underlying basis for a constellation of thirteen stars in a hemispheric arrangement. (This hemisphere represents the zodiac.) This constellation appeared on several early thirteen-star flags. A hemisphere of stars (representing the zodiac) appears above the head of an eagle in the *The Columbian Almanac, or the North-American Calendar, for the Year of our Lord, 1791* (Wilmington, DE: Andrews, Craig, and Brynberg, 1790). According to scholar Pamela Scott, an arch in the White House is decorated in a similar fashion (personal communication with the author, 2014).

63. Michael Judge, *The Dance of Time: The Origins of the Calendar* (New York: Arcade, 2004), 29. See also Eran Shalev, "A Republic Admidst the Stars: Political Astronomy and the Intellectual Origins of the Stars and Stripes," *Journal of the Early Republic* 31, no. 1 (Spring 2011): 39–74.

CHAPTER 4

64. Jane Hope, *The Secret Language of the Soul: A Visual Guide to the Spiritual World* (San Francisco: Chronicle Books, 1997), 16.

65. Erich Neumann, *The Great Mother: An Analysis of the Archetype* (Princeton: Princeton University Press, 1963); E. O. James, *The Cult of the Mother-Goddess: An Archaeological and Documentary Study* (New York: Praeger, 1959); Robert Graves, *The White Goddess: A Historical Grammar of Poetic Myth* (New York: Farrar, Straus, and Giroux, 1948); and Elinor Gadon, *The Once and Future Goddess: A Symbol for Our Time* (New York: Harper & Row, 1989), 7.

66. W. Robertson Nicoll, ed., *Expositor's Greek Testament* (Grand Rapids, MI: Eerdmans, 1951), 423. The iconography of the Virgin Mary retains attributes of the mother goddess and harkens back to the Babylonian Damkina, mother of the god Marduk and "queen of the heavenly tiara" (423). Marduk was the patron god of Babylon. Marduk's role is defined in the Enuma Elish, the Babylonian creation myth that justifies his rise as leader of the Babylonian pantheon.

67. Roberts, *Encyclopedia of Comparative Iconography,* 961.

68. Nicoll, *Expositor's Greek Testament,* 423.

69. Maurice Vloberg, "The Iconographic Types of the Virgin in Western Art," in *Mary: The Complete Resource,* ed. Sarah Jane Boss (New York: Oxford University Press, 2007). Vloberg notes that the Madonna with child was painted on the vault of a funeral chamber in the early second century (541). See also Eva De Visscher, "Marian Devotion in the Latin West in the Latter Middle Ages," in *Mary: The Complete Resource.* De Visscher writes that the Virgin Mary is depicted crowned with twelve stars (zodiac) on a stained glass window (circa 1150 AD) in the old church of Notre Dame in Paris. For more on the Christianized zodiac, see *The New Catholic Encyclopedia,* 2nd ed., vol. 13 (Detroit: Thomson/Gale, 2003), 668.

70. Moriz Sondheim, "Shakespeare and the Astrology of His Time," *Journal of the Warburg Institute* 2, no. 3 (January 1939): 245.

71. Edward D. O'Connor, *Dogma of the Immaculate Conception, History and Significance* (Notre Dame, IN: University of Notre Dame Press, 1958), 463. See also Boss, *Mary: The Complete Resource.*

72. Jameson, *Legends of the Madonna,* 130.

73. James H. McConkey, *The Book of Revelation* (Pittsburgh: Silver Publishing Society, 1921), 7.

74. Leland Ryken, James C. Wilhoit, and Tremper Longman III, *Dictionary of Biblical Imagery* (Downers Grove, IL: Inter Varsity, 1998), 713; and *The New Interpreter's Bible,* vol. 12 (New York: Abingdon-Cokesbury, 1998).

75. James Hall, *Dictionary of Subjects and Symbols in Art* (New York: Harper-Collins, 1994), chap. 5 (323–335), discusses Virgil's use of cosmic imagery. The Bible employs cosmic imagery in its depiction of the struggle between the forces of good and evil. For additional information on New Testament cosmic imagery, see Ryken, Wilhoit, and Longman, *Dictionary of Biblical Imagery,* 715.

76. Jameson, *Legends of the Madonna,* 130–131.

77. Karl Josef Holtgen, introduction to *Partheneia Sacra* by Henry Hawkins (Brookfield, VT: Scolar Press/Ashgate, 1993).

78. Jean Delanglez, "Franquelin, Mapmaker," *Mid America: An Historical Review* 25, no. 14 (1943): 29–74; and *Dictionary of Canadian Biography,* vol. 2 (Toronto: University of Toronto Press, 1969), 228–231. The Franquelin map, *Carte generalle de la Nouvelle France,* is a facsimile of the original (in Box #11, #415) and is part of the Louis Charles Karpinski Collection (FAC 945) at the Huntington Library. The original map is at the Library of the Service Hydrographique de la Marine in Paris. The bottom of the facsimile map has the following marks: "Paris. Serv. Hyd. Bib. 4044. C 1035X HA?" In an e-mail message to the author on May 11, 2012, Vin Steponaitis, an expert on this map, stated that he doesn't know where this map is located in France.

79. Bernard Bailyn, *To Begin the World Anew: The Genius and Ambiguities of the American Founders* (New York: Random House, 2003).

80. Olson, *Benjamin Franklin's Vision*. See also Phoebe Lloyd Jacobs, "John James Barralet and the Apotheosis of George Washington," *Winterthur Portfolio*, no. 12 (1977): 115–137; George Wildenstein, *The Paintings of Fragonard* (Garden City, NY: Doubleday, 1960); and Matilde Battistini, *Symbols and Allegories in Art: A Guide to Imagery*, trans. Stephen Sartarelli (Los Angeles: J. Paul Getty Museum, 2002), 30. Charles Thomson, secretary to the Continental Congress, employed zodiac imagery on the Great Seal. He also selected the motto *Novus ordo seclorum* ("new order of the ages"). The motto is derived from the zodiac and may underlie the symbolism of Virgil's Fourth Eclogue. See Richard S. Patterson and Richardson Dougall, *The Eagle and the Shield: A History of the Great Seal of the United States* (Washington, DC: US Government Printing Office, 1976).

 Two of the most widely read books in eighteenth-century America were the Bible and the almanac, which, like the Bible, appeared in various editions. The annual almanac contained a calendar with the times of the daily sunrise and sunset, astronomical data, and other information and often included illustrations of the zodiac and the Milky Way.

81. Samuel Sherwood, "The Church's Flight into the Wilderness [1776]," in *Political Sermons of the American Founding Era, 1730–1805*, 2nd ed., vol. 1, ed. Ellis Sandoz (Indianapolis: Liberty Fund, 1998), 505.

82. Ezra Stiles, *The United States Elevated to Glory and Honor*, 2nd ed. (Worcester, MA: Isaiah Thomas, 1785), 58, 89, 98.

83. Milton Atchison Reckford, *Guide Book and Descriptive Manual of Battle Flags in Flag Room of State-House at Annapolis, Maryland* (Annapolis, MD, 1934), 5. The Smithsonian conducted a textile analysis and determined the Maryland flag to be from the nineteenth century, although the canton design is from the eighteenth century; Grace Rogers Cooper, *Thirteen-Star Flags: Keys to Identification* (Washington, DC: Smithsonian Institution Press, 1973), 28.

84. Alan Russet, *Dominic Serres (1719–1793): War Artist to the Navy* (Woodbridge, England: Antique Collector's Club, 2001), 196; and Dominick Serres and John Thomas Serres, *Liber Nauticus and Instructor in the Art of Marine Drawing* (London: Scholar, 1979), unnumbered plate representing flags of different nations and plate XXXI.

85. Charles Coleman Sellers, *The Artist of the Revolution: The Early Life of Charles Willson Peale* (Hebron, CT: Feather and Good, 1939); Lillian B Miller, ed., *The Selected Papers of Charles Willson Peale and His Family* (New Haven, CT: Yale University Press, 1983); and Charles Willson Peale MSS Diary (December 4, 1776–January 20, 1777) (HM 974, Manuscripts, Huntington Library, San Marino, CA). See also Donald Egbert, "General Mercer at the Battle of Princeton as Painted by James

Peale, Charles Willson Peale and William Mercer," *Princeton University Library Chronicle* 8, no. 4 (Summer 1952): 171–194.

86. Christie, Manson & Woods International, Inc., *George Washington at Princeton: Property from the Collection of Mrs. J. Insley Blair* (New York: Christie's, 2006); Carol Vogel, "Inside Art," *New York Times*, June 24, 2005; *Exhibition of Portraits by Charles Willson Peale and James Peale and Rembrandt Peale* (Philadelphia: Pennsylvania Academy of the Fine Arts, 1923); and Graham Hood, "Easy, Erect and Noble," *Journal of the Colonial Williamsburg Foundation* 24, no. 2 (Summer 2002): 52–57.

 Claude Harkins, a well-known collector of American flags, owns a thirteen-star American flag that he claims is eighteenth century in origin. The canton is a circle of stars with one star in the center (personal communication with the author, 2012).

CHAPTER 5

87. Shields, *American Aeneas*.

88. Meyer Reinhold, *Classical Americana: The Greek and Roman Heritage in the United States* (Detroit: Wayne State University Press, 1984); Caroline Winterer, "From Royal to Republican: The Classical Image in Early America," *Journal of American History* 91, no. 4 (March 2005): 1264–1290; and Caroline Winterer, *The Culture of Classicism: Ancient Greece and Rome in American Intellectual Life, 1780–1910* (Baltimore: Johns Hopkins University Press, 2002).

89. Carl J. Richard, *The Founders and the Classics: Greece, Rome, and the American Enlightenment* (Cambridge MA: Harvard University Press, 1994), 12; Margaret R. Scherer, *The Legends of Troy in Art and Literature* (New York: Phaidon, 1963), 206–210; Nigel Spivey and Michael Squire, *Panorama of the Classical World* (Los Angeles: J. Paul Getty Museum, 2004), 108–139; and John Roberts, ed., *The Oxford Dictionary of the Classical World* (New York: Oxford University Press, 2007), 490–491.

90. Shields, *American Aeneas*.

91. Ibid.

92. *Encyclopedia Americana* (Danbury, CT: Grolier, 1994), 758; and Marina Warner, *World of Myths* (London: British Musem Press; Austin: University of Texas Press, 2003).

93. Fagles, *Virgil: Aeneid*, chap. 8, lines 778 ("dropped from heaven"), 738–39 ("story of Italy").

94. Sylvanus Morgan, *The Sphere of Gentry* (London: William Leybourn, 1661).

95. Fagles, *Virgil: Aeneid*, 33.

96. Ibid, 13.

97. Shields, *American Aeneas*, xxv.

98. Humphrey Wine, *Claude: The Poetic Landscape* (London: National Gallery Publications, 1994); Marcel Rothlisberger, *Claude Lorrain: The Paintings* (New Haven, CT: Yale University Press, 1961); and Johannes B. Rietstap, *Armorial Général: Précédé d' un Dictionnaire des Termes du Blason,* vol. 1 (Baltimore: Genealogical Publishing, 1972), 58.

99. Jenny Marsh, ed., *Cassell Dictionary of Classical Mythology* (London: Wellington House, 1998), 192; and Edward Tripp, *Crowell's Handbook of Classical Mythology* (New York: Thomas Y. Crowell, 1970), 379.

100. Pierre Grimal, *The Dictionary of Classical Mythology* (Malden, MA: Blackwell, 1996), 193–94.

101. Hall, *Dictionary of Subjects and Symbols.*

102. Cynthia J. Bannon, *Brothers of Romulus: Fraternal Pietas in Roman Law, Literature, and Society* (Princeton: Princeton University Press), 166.

103. Roberts, *Oxford Dictionary of the Classical World,* 295, 333, 490.

104. Warner, *World of Myths,* 117.

105. George Fisher, in *American Instructor* (Philadelphia: B. Franklin and D. Hall, 1748), writes: "having spilt some of the Milky out of his mouth he whited that part of the sky that is called the Milky Way" (309).

106. Patterson and Dougall, *The Eagle and the Shield,* 15–19.

107. Olson, *Benjamin Franklin's Vision,* 252.

108. Driskel, "By the Light of Providence."

109. For a definition of milk, see Jack Tresidder, *Dictionary of Symbols* (San Francisco: Chronicle Books, 1997), 133.

110. J. G. F. Powell and Niall Rudd, introduction to *Cicero: The Republic and the Laws,* trans. Niall Rudd (New York: Oxford University Press, 1998).

111. E. Edson and E. Savage-Smith, *Medieval Views of the Cosmos* (Oxford: Bodleian Library, 2004), 25.

112. Ptolemy, *Almagest,* trans. G. J. Toomer (Princeton: Princeton University Press, 1998).

113. *The Etymologies of Isadore of Seville,* trans. Stephen A. Barney et al., (Cambridge: Cambridge University Press, 2006), 101.

114. G. P. Goold, ed., *Manilius: Astronimica* (Cambridge, MA: Harvard University Press, 2006), 65, 69.

115. Ernest Lehner and Johanna Lehner, *Astrology and Astronomy: A Pictorial Archive of Signs and Symbols* (Mineola, NY: Dover, 1992), 29, 33–36.

116. A warrior, Er died on a battlefield. When the dead were picked up to be disposed of, their bodies were putrid. But when Er was picked up, his corpse was fresh. While on the funeral pyre, Er revived; he subsequently told the funeral attendees about what he had seen in the world beyond. Plato describes Er's experience in terms that encompass the cosmological importance of the Milky Way and the zodiac. Plato writes that judges render judgment over the dead; just souls go

upward through one celestial gate in the heavens, while the unjust go through a gate on earth. More important, Plato describes the celestial gate or opening as a broad ribbon of zodiacal light that intersects the Milky Way (the cosmic X that Plato describes in *Timaeus*. See Donald J. Zeyl, "*Timaeus*," in John M. Cooper, ed., *Plato's Complete Works* [Indianapolis: Hackett, 1997], 1224–1291). See also Plato's *Republic* in Cooper, *Plato's Complete Works* (1217–23). John Adams was a devoted student of the classics and owned a ten-volume series of Plato's works, which he donated to the Boston Public Library.

CHAPTER 6

117. George Henry Chase, "The Shield Devices of the Greeks," *Harvard Studies in Classical Philology* 13 (1902): 93–127.

118. British Museum, *A Guide to the Antiquities of Roman Britain* (London: British Museum, 1922), 77–79.

119. M. R. Wright, *Cosmology in Antiquity* (London: Routledge, 1996), 1–10. See also Philip Hardie, *Virgil's Aeneid: Cosmos and Imperium* (Oxford: Oxford University Press, 2003).

120. The center of the shield is the curved boss. See Robert Fagles, trans., *The Iliad* (New York: Penguin, 1990), book 18, lines 558–709. In "Der Child des Achilleus," Rita Amedick writes that the first appearance of Achilles' shield in the visual arts in a form closely related to Homer's description is a second-century B.C. shield relief in Rome's Museo Capitolino. See Rita Amerdick, "Der Child des Achilleus in Hellenistisch-Romischen Ikonographischen Tradition," *Jahrbuch des Deutschen Archaologischen Instituts* 14 (1999): 157–206. See also Klaus Fittschen, *Archaeologia Homerica: Der Schild des Achilleus* (Göttingen: Vandenhoeck & Ruprecht, 1973).

121. For a description of Achilles' shield, see Fagles, *The Iliad*, book 18, lines 557–720.

122. Chase, "Shield Devices of the Greeks," provides descriptions of shields from the Mycenaean Age, the Homeric Age, and the historical period. For Homeric literary sources, see p. 68.

123. Riemer Faber, "Vergil's 'Shield of Aeneas' and the Shield of Heracles," *Mnemosyne* 53, no. 1 (2000): 49–57. Achilles' shield as described in *The Iliad* is the literary model for the ekphrasis (description) of the shield of Aeneas. Benjamin Franklin, an admirer of the work of printer John Baskerville, purchased six copies of Baskerville's version of Virgil's *Aeneas* in 1757. See also Josiah Henry Benton, *John Baskerville: Type-Founder and Printer, 1706–1775* (Boston: Privately Printed, 1914).

124. Fagles, *Virgil: Aeneid*, 33.

125. Ibid.

126. Hardie, *Virgil's Aeneid.*

127. Rietstap, *Armorial Général*. See also Frank J. Coppa, *Encyclopedia of the Vatican and Papacy* (Westport, CT: Greenwood, 1999), 96. A rectangular blue flag with stars has been known as "Aeneas's flag" since artist Claude Lorrain placed the flag on Aeneas's ship in *The Landing of Aeneas at Palanteum* in 1675.

Pope Clement X was born Emilio Altieri into a distinguished Roman family on July 12, 1590. Ordained in 1624, he was elected pope in 1669 at the age of 79. He appointed his nephew, Paoluzzi degli Albertoni, as cardinal. Albertoni married a niece of Clement's; he added the name Altieri to his own and spent vast sums of money on his Palazzo Altieri. Albertoni's son, Gasparo, commissioned Lorrain to paint *The Arrival of Aeneas at Palanteum*. After the election of Pope Clement X, both Gasparo Albertoni and his father took the Altieri name and the title of prince. They claimed descent from Aeneas, and their family arms decorate the flag on Aeneas's ship in the painting; Clement X's arms included six stars with eight points in a 3-2-1 arrangement. See Wine, *Claude*, 49–50. A drawing of *The Landing of Aeneas at Pallanteum* was in the collection of the Duke of Devonshire; in that drawing, the ensign is in the foreground, although the ensign's appearance is not clear. See Claude Lorrain, *Liber Veritatis, or, A Collection of Prints, After the Original Designs of Claude Lorrain* (London: Hurst, Robinson, and Co., 1819); Anthony Blunt, *Art and Architecture in France: 1500 to 1700* (Hammondsworth: Penguin, 1957); and Michael Kitson, "The 'Altieri Claudes' and Virgil," *Burlington* 102, no. 688 (1960): 312–318.

128. See Donald L. Galbreath, *A Treatise on Ecclesiastical Heraldry,* Part 1, *Papal Heraldy* (Cambridge: W. Heffer and Sons, 1930), 63–99.

129. Adam Bartsch, *The Illustrated Bartsch* (New York: Abaris, 1985).

130. Coats of arms bearing stars are examples of ecclesiastical heraldry in the Italian Roman Catholic Church. See Wine, *Claude*, 98: "Prince Gasparo Altieri must therefore have commissioned it as a pendant to No. 36 soon after Cardinal Altieri had been elected Pope Clement X in 1670. Claude's inscription on a preparatory drawing states that Gasparo requested the subject of Aeneas showing the olive branch to Pallas as a sign of peace. Gasparo may have wanted to have Aeneas represented as an allusion to his own princely status."

131. Morgan, *Sphere of Gentry*. Morgan believes that Aeneas's shield was a circular shield but acknowledges that shield shapes (circles, ovals, bows, squares) have no significance in heraldry. Rhode Island star shields mimic the frontispiece in Morgan's *Sphere of Gentry*. See also William Smith and Theophilus D. Hall, *A Copious and Critical*

English-Latin Dictionary: A Dictionary of Proper Names (New York: American Book Company, 1871), 736.

132. Andrea Alciati, *Declaracion Magistral Sobre la Emblemas de Andres Alciato* (Menston: Scolar Press, 1973). Early editions of this book, published in Lyons, did not include a shield of stars. The edition published in Valencia in 1655 does have a shield of thirteen stars. It is not known which edition Franklin owned.

133. Sarah Jackson, ed., *A Journal of Samuel Powel* (Florence: Studio per Edizioni Scelte, 2001); and John Morgan, *The Journal of Dr. John Morgan, of Philadelphia, from the City of London, 1764: Together with a Fragment of a Journal Written at Rome, 1764, and a Biographical Sketch* (Philadelphia: Lippincott, 1907). The original journal resides in the Harvard Library.

134. Jackson, *Journal of Samuel Powel*, 38–39.

135. The painting remained at the Altieri palace in Rome until 1799, when it was sold.

CHAPTER 7

136. Thomas Woodcock and John Marin Robinson, *The Oxford Guide to Heraldry* (Oxford: Oxford University Press, 1988), 50.

137. Patterson and Dougall, *The Eagle and the Shield*. See also John C. Fitzpatrick, ed., *The Writings of George Washington from the Original Manuscript Sources*, vol. 30 (Washington, DC: US Government Printing Office, 1931–44), "George Washington to William Barton, September 7, 1788, 87–88."

138. Patterson and Dougall, *The Eagle and the Shield*, 128–170.

139. Ibid., 83.

140. In *The Eagle and the Shield*, Patterson and Dougall note heraldic terms that were unique to the Great Seal that were worthy of being redefined in a glossary (572–577). I encourage readers to refer to this glossary because it discusses eighteenth-century usage of seals.

141. Howard M. Chapin, *Illustrations of the Seals, Arms, and Flags of Rhode Island* (Providence: Rhode Island Historical Society, 1930).

142. Sinclair Hamilton, "The Earliest Devices of the Colonies and Some Other Early Devices," *Princeton University Library Chronicle* 10, no. 3 (April 1949): 117–123. The first device, in 1774, had twelve hands and arms; by 1775, there were thirteen hands and arms. Hamilton states that the device appears in more elegant form in Abraham Swan's, "A Collection of Designs in Architecture," in Charles T. Evans, Clifford K. Shipton, and James E. Mooney eds., *National Index of American Imprints through 1800: The Short-Title Evans* (Worcester, MA: American Antiquarian Society and Barre Publishers, 1969), entry no. 14481.

143. Alfred Coxe Prime, *The Arts and Crafts in Philadelphia, Maryland, and South Carolina: 1721–1785* (New York: Walpole Society, 1929); and David

C. R. Heisser, "Warrior Queen of Ocean: The Story of Charleston and Its Seal," *South Carolina Historical Magazine* 93, no. 34 (1992): 167–195.

144. See the *Coin and Currency Collections* website, hosted by the University of Notre Dame Libraries, Department of Special Collections, www.coins.nd.edu/ColCurrency/CurrencyText/SC-02-08-79.html; and William Smith and Theophilus Hall, *A Copious and Critical English-Latin Dictionary* (New York: American Book Company, 1871), https://archive.org/details/copiouscriticaleoosm.

145. *Coin and Currency Collections,* www.coins.nd.edu/CoCurrency/CurrencyText/SC-02-08-79.html; and Erik Goldstein, curator for coins and paper currency, Colonial Williamsburg Foundation, Williamsburg, VA, personal communication with the author, August 2, 2010.

146. Miller, *Selected Papers of Charles Willson Peale*; and Evans, Shipton and Mooney, *National Index of American Imprints*. See also Egbert, "General Mercer at the Battle of Princeton," 184–185.

147. Evans, Shipton, and Mooney, *National Index of American Imprints.*

148. Jane Turner, ed., *The Dictionary of Art*, vol. 8 (New York: Oxford University Press, 2006), 528–529. See also Mathias Darly, *Two Rebuses from the American Revolution in Facsimile* (Washington, DC: US Library of Congress, 1973); Joan D. Dolmetsch, *Rebellion and Reconciliation: Satirical Prints on the Revolution at Williamsburg* (Charlottesville: University Press of Virginia, 1976); and E. McClung Fleming, "The American Image as Indian Princess, 1765–1783," *Winterthur Portfolio* 2 (1965): 79.

149. Thomas Konig, *Le Politique Hollandais* (Amsterdam: J. A. Crajenschat & A. M. Cerisier, 1781).

150. Boleslaw Mastai and Marie-Louise D'Otrange Mastai, *The Stars and the Stripes: The American Flag as Art and as History from the Birth of the Republic to the Present* (New York: Alfred A. Knopf, 1973), 23.

151. For a description of *Libera Soror*, see J. F. Loubat, *The Medallic History of the United States of America, 1776– 1876,* vol. 1 (New York: J. F. Loubat, 1878), 57–73.

152. Ibid., 57.

153. Ibid.

154. Information Sheet from the Office of the Curator, Supreme Court of the United States (updated Dec. 3, 2009).

CHAPTER 8

155. Carol B. Cadou, *The George Washington Collection: Fine and Decorative Arts at Mount Vernon* (Manchester, VT: Hudson Hills, 2006), 13.

156. Jules David Prown, *Art as Evidence: Writings on Art and Material Culture* (New Haven, CT: Yale University Press, 2001), 221.

157. Ibid.

158. Ibid., 221–222.

159. Ibid., 70.

160. Anna A. Trofimova, *Ancient Greeks on the Black Sea: Ancient Art from the Heritage* (Los Angeles: J. Paul Getty Museum, 2007), 185–187. Phrygian caps were worn by inhabitants of Anatolia (now Turkey). Slaves wore plain caps. Morgan, *Sphere of Gentry,* 57, notes that priests who guarded Aeneas's shield of stars wore Phrygian caps.

161. For more on Saturnalia, see Roberts, *Oxford Dictionary of the Classical World,* 679.

162. For more on Feronia, see Grimal, *Dictionary of Classical Mythology,* 165. See also George Henry Preble, *History of the Flag of the United States* (Boston: A. Williams and Company, 1880), 254.

163. Preble, *History of the Flag,* 254; and Patterson and Dougall, *Eagle and the Shield,* 16–21.

164. David H. Fischer, *Liberty and Freedom: A Visual History of America's Founding Ideas* (New York: Oxford University Press, 2005); and Zieber, *Heraldry in America.*

165. Charles James, *New and Enlarged Military Dictionary,* 2nd ed. (London: Military Library, 1805), 843.

166. Walter W. Skeat, *An Etymological Dictionary of the English Language* (Oxford: Clarendon, 1963), 517. See also Alice Mackrell, *Shawls, Stoles and Scarves,* (London: B. T. Batsford, 1986), 13; Hew Strachan, *British Military Uniforms 1768–1796: The Dress of the British Army from Official Sources* (London: Arms and Armour Press, 1975); and Stephen Pell, "The Gorget as a Defense, as a Symbol, and as an Ornament," *Bulletin of Fort Ticonderoga Museum* 4, no. 23 (September 1937): 126–141.

167. Smith, *Flags through the Ages,* 265.

168. Cadou, *George Washington Collection,* 26. An invoice in Washington's letter book dated October 23, 1754, cites one crimson military sash. See also George C. Neumann and Frank J. Kravic, *Collector's Illustrated Encyclopedia of the American Revolution* (Texarkana, TX: Scurlock, 1990), 236.

169. Harold Peterson, *Book of the Continental Soldier* (Harrisburg, PA: Stackpole, 1968), 242.

170. John Fitzpatrick, *Writings of George Washington,* vol. 3 (Washington, DC: US Government Printing Office, 1931–44), 338–339.

171. Harold Langley notes the existence of a photo of Washington's blue sash in the Smithsonian (personal letter to the author, October 28, 2006). See also Stanislaus M. Hamilton, *Letters to Washington and Accompanying Papers,* vol. 5, *1774–1775* (Cambridge, MA: Riverside, 1902), 65, where a vendor describes a sash he is sending to George

Washington; and "George Washington Pocket Day Book or Cash Memorandum begun 25 March 1774" (facsimile manuscript, call number 909, Huntington Library): Purchase of a sash from Mr. Milnor, October 15, 1774, and November 29, 1774.

172. Charles H. Callahan, *Washington: The Man and the Mason* (Whitefish, MT: Kessinger, 1913), 350. An inventory of the contents of the Mount Vernon estate upon Washington's death includes "1 Silk Sash (Military)."

173. Mark A. Tabbert, *American Freemasons: Three Centuries of Building Communities* (New York: New York University Press, 2005), 45; and Bernard R. Jones, *Freemason's Guide and Compendium* (Nashville: Cumberland House, 2006).

174. Steven C. Bullock, *Revolutionary Brotherhood: Freemasonry and the Transformation of the American Social Order, 1730–1840.* (Chapel Hill: University of North Carolina Press, 1996), 106. A sash appears on a painting of a British mason in the 1770s, but it is not known if sashes were commonly worn in America at that time. See also Jones, *Freemason's Guide.*

175. Schuyler Hamilton, *Our National Flag—The Star-Spangled Banner: The History of It* (New York: Lockwood, 1887), 405; and P. Hume Brown, *A Short History of Scotland* (Edinburgh: Oliver and Boyle, 1951).

176. Ivor H. Evans, *Brewer's Dictionary of Phrase and Fable* (New York: Harper & Row, 1981), 131, 281. Covenanters based their choice on Numbers 15: 38.

177. Cadou, *George Washington Collection,* 213.

178. Peterson, in *Book of the Continental Soldier,* 243, states that in portraits made in 1779–80, George Washington appears with three small star-shaped rosettes of gold lace on his epaulettes. After 1780, he appears in portraits with three silver stars in place of gold rosettes. Washington had no specific insignia as commander-in-chief; however, in general orders for June 18, 1780, major generals were ordered to wear two stars on each epaulette. See also Fitzpatrick, *Writings of George Washington;* and John Rhodehamel, *The Great Experiment: George Washington and the American Republic* (New Haven, CT: Yale University Press, 1998) 162–163.

179. Patterson and Dougall, *Eagle and the Shield,* 62.

180. Ibid., 65.

181. Dorothy Hoobler and Thonas Hoobler, *Captain John Smith: Jamestown and the Birth of the American Dream* (Hoboken, NJ: Wiley, 2006).

182. William M. Kelso, *Jamestown: The Buried Truth* (Charlottesville: University of Virginia Press, 2006), 91, 121; and George Cameron Stone, *A Glossary of the Construction, Decoration and Use of Arms and Armor in All Countries and in All Times: Together with Some Closely Related Subjects* (New York: Jack Brussel, 1961).

183. Pell, "The Gorget as a Defense." See also Strachan, *British Military Uniforms*; and Harold Peterson, *Arms and Armor in Colonial America, 1526–1783* (Mineola, NY: Dover), 312.

184. Peterson, *Arms and Armor in Colonial America*, 311–313. Hamilton, *Letters to Washington*, contains a letter regarding the purchase of George Washington's gorget in November 1774.

185. Cadou, *George Washington Collection*, 22.

186. The gorget was purchased by the Charleston Museum from a relative of the Pinckney family. See Herman W. Williams, "American Silver Gorget," *Military Collector and Historian* 13, no. 2 (1961): 55; and E. Milby Burton, *South Carolina Silversmiths, 1690–1860* (Rutland, VT: C. Tuttle, 1968).

187. The reverse side of the gorget bears the stamp "I Vanall," framed in a rectangle; John Vanall worked as a Charleston silversmith from 1749 to 1752. See also Burton, *South Carolina Silversmiths*, 96; and Marvin R. Zahniser, *Charles Cotesworth Pinckney: Founding Father* (Chapel Hill: University of North Carolina Press, 1967).

188. Ulysse Desportes, "Giuseppe Ceracchi in America and His Busts of George Washington," *Art Quarterly* 26 (summer 1963): 141–179.

189. Jane Davidson Reid and Chris Rohman, *The Oxford Guide to Classical Mythology in the Arts, 1300–1900s* (New York: Oxford University Press, 1993), 241. Athena/Minerva was also called Pallas ("brandisher of arms") and is often depicted with an aegis on her breast and a gorgon's head on her shield. Her shield is usually noted as being constructed of goatskin.

190. Helen Wallis and Arthur Howard Robinson, *Cartographical Innovations: An International Handbook of Mapping Terms to 1900* (Hertfordshire, England: Map Collector Publications, 1987), 247.

191. Henry Moeller, "One Sovereign Flag: Mulitple Designs and Uses," *NAVA News* 35, no. 2 (April–June 2002), 2–5.

192. Zieber, *Heraldry in America*, 197.

193. Newman, *Early Paper Money*, 66, 67. In ancient Egypt, the eye of Horus was a sun motif. The right eye of Horus was the sun and the left eye was the moon. The sun motif in European medallic art was sometimes shown as the eye of providence. This motif first appeared in the United States when Pierre Du Simitiere introduced it on his Great Seal design in 1776. He also used it on a medal presented to George Washington upon the evacuation of Boston on March 17, 1776.

194. The image of the earth with a band around it is an example of globe and belt imagery (*balteus orbe*—the belt of the heavens). It first appeared on a Roman coin nearly two thousand years ago (81–84 AD). See C. H. V. Sutherland, *Roman Coins* (London: Barrie & Jenkins, 1975), 190. The belt is usually divided into twelve parts, one for each sign of the zodiac. The zodiac motif also appears in seventeenth- and

eighteenth-century European emblem books. See Peter M. Mader and Guntter Mattern, *Fahnen und ihre Symbole* (Zurich: Schweizerisches Landsmuseum, 1993), 8; and Ronald Brashear and Daniel Lewis, *Star Struck: One Thousand Years of the Arts and Science of Astronomy* (Seattle: University of Washington Press, 2001), 14–17.

195. Howard M. Madaus, "Novo Constellation: The Story of a Shared Heritage," *Numismatist* (February 1983): 238–245.

196. Ryken, Wilhoit, and Longman, *Dictionary of Biblical Imagery,* 437; abbreviations omitted.

197. *Interpreter's Bible,* 533. See also "The Spiritual Odyssey of Jacob Duché," *Clarke Garrett Proceedings of the American Philosophical Society* 119, no. 2 (April 16, 1976), 143–155. Francis Hopkinson's use of New Jerusalem symbolism appears to have originated with Jacob Duche, his brother-in-law. See Mason I. Lowance, Jr. and David Watters, "Increase Mather's 'New Jerusalem': Millenialism in Late Seventeenth Century New England," *Proceedings of the American Antiquarian Society* 87, no. 2 (1977): 343–408.

198. George E. Hastings, *The Life and Works of Francis Hopkinson* (Chicago: University of Chicago Press, 1926). One of Mrs. Hopkinson's favorite books was Thomas Newton's *Dissertations on the Prophecies.* See also Hopkinson's letter to his mother, March 9, 1767 (143–144).

199. Ibid. Francis Hopkinson met and dined with Thomas Newton, the Bishop of Bristol, in England in 1767. Newton gave Hopkinson a copy of his book *Dissertations on the Prophecies.* Newton's imagery deals with emblems and symbols from Revelation and the Roman Empire.

CHAPTER 9

200. Bray, *Diary of John Evelyn,* 357.

201. Michel Pastoureau, *The Devil's Cloth: A History of Stripes and Striped Fabric* (New York: Columbia University Press, 1991), 5.

202. Peleg D. Harrison, *The Stars and Stripes and Other American Flags* (Boston: Little, Brown, 1906), 65.

203. Ibid., 41.

204. The official origin of the striped flag is obscure. See Preble, *History of the Flag,* 245. See also Furlong and McCandless, *So Proudly We Hail*; and Moeller, *Shattering an American Myth.*

205. For the early history of red and white stripes in America, see Furlong and McCandless, *So Proudly We Hail*; and Moeller, *Shattering an American Myth.*

206. Eusebius Pamphilius, "Church History, Life of Constantine, Oration in Praise of Constantine," in Philip Schaff, ed., *Nicene and Post-Nicene Fathers, Series II, Volume I,* ch. 28 (https://www.ccel.org/ccel/schaff/npnf201). See also Elizabeth Hartley, Jane Hawkes, Martin Henig, and

Francis Mee, eds., *Constantine the Great: York's Roman Emperor* (Marygate, England: York Museum Trust, 2006), 24; J. C. Metford, *Dictionary of Christian Lore and Legend* (London: Thomas & Hudson, 1983), 108; Richard Viladesau, *The Beauty of the Cross* (New York: Oxford University Press, 2006), 43; and Preble, *History of the Flag*, 59.

207. Viladesau, *Beauty of the Cross*, 43–44.

208. George Willard Benson, *The Cross: Its History and Symbolism* (Mineola, NY: Dover, 2005), 30.

209. Metford, *Dictionary of Christian Lore and Legend*; and Hartley et al., *Constantine the Great.*

210. Viladesau, *Beauty of the Cross*; and Preble, *History of the Flag.*

211. Tresidder, *Dictionary of Symbols*, 119.

212. Michael Jordan, *Encyclopedia of Gods: Over 2,500 Deities of the World* (New York: Facts on File, 1993). See also Meher McArthur, *Reading Buddhist Art: An Illustrated Guide to Buddhist Signs and Symbols* (New York: Thames & Hudson, 2002).

213. Peter Mantin and Ruth Mantin, *The Islamic World: Beliefs and Civilizations, 600–1600* (Cambridge: Cambridge University Press, 1993).

214. W. Fritz Volbach, *Early Decorative Textiles* (London: Paul Hamlyn, 1989).

215. Peter Gwynn-Jones, Garter Principal King of Arms at the College of Arms in the United Kingdom, noted that he is not familiar with any red and white combinations prior to Richard I (personal communication with the author, September 5, 2005). St. George appeared to Richard I before the siege of Antioch and promised him victory, after which Richard I declared St. George to be the patron saint of England. Smith, *Flags through the Ages*, 41, provides an illustration from the time of Alonso X the Wise, King of Leon and Castile (1252–84), in which Spanish knights carry red and white lance pennants.

 In representations, St. Michael can be distinguished from St. George by his wings and by the way he fights the dragon (see Revelation 12:7–9). St. Michael fights the dragon on foot or in the air; St. George is always mounted on a horse. See Gaston Duchet-Suchaux and Michel Pastoureau, "The Bible and the Saints," *The Art Book* 2, no. 1 (January 1995), 18a.

216. Metford, *Dictionary of Christian Lore and Legend*, 108.

217. During the early Middle Ages (circa 1100–1453), a number of European nations that participated in the Crusades used the cross as well as red and white stripes. Each nation appears to have chosen a different color cross. During the late Middle Ages, red and white stripes assumed a heraldic connotation and function. See Smith, *Flags through the Ages*, 26.

218. "The power of religion depends, in the last resort, on the credibility of the banners it puts in the hands of men as they stand before death, or more accurately, as they walk, inevitably towards it," Peter Berger,

quoted in Carolyn Marvin and David W. Ingle, eds., *Blood, Sacrifice and the Nation: Totem Rituals and the American Flag* (Cambridge: Cambridge University Press, 1999), 1.

According to Ryken, Wilhoit, and Longman, the Bible contains fewer than a dozen references to banners. In the majority of cases, the banner of victory in the Old Testament is ascribed to God (e.g., Psalms 20:5 and 60:4)—the writers believe that God won victories for Israel. In the New Testament, Jesus Christ is the divine warrior, and he brings about victory and rids the earth of evil. See Ryken, Wilhoit, and Longman, *Dictionary of Biblical Imagery,* 70. (In addition to the references to banners, the Bible also contains nine entries for "flag" and twenty-three for "standard.")

219. Tresidder, *Dictionary of Symbols,* 119. See also James H. Beck, *Raphael* (New York: Harry N. Abrams, 1994); Luitpold Dussler, *Raphael: A Critical Catalogue of His Pictures, Wall Paintings, and Tapestries* (London: Phaidon, 1971); and Konrad Oberhuber, *Raphael: The Paintings* (Munich: Prestal Verlag, 1999).

220. Moeller, *Shattering an American Myth.*

221. Vincenzo Maria Coronelli, *Mare del Nord, 1680* (cartouche; Map #105: 330, Huntingdon Library).

222. Jean Sutton, *Lords of the East* (London: Chrysalis Group, 2000); Charles Fawcett, "The Striped Flag of the East India Company and Its Connexion with the American 'Stars and Stripes,' " *Mariner's Mirror 23* (1939): 449–476; and Peter Ansoff, "Sir Charles Fawcett Redux: The Historical Connection between the East India Flag and the American Continental Colors," *Proceedings of the 24th International Congress of Vexillology,* Washington, DC (August 1–5, 2011).

223. Moeller, *Shattering an American Myth*; and Barney et al., *Etymologies of Isidore of Seville,* 360–361.

224. *Journals of the Provincial Congress, Provincial Convention, Committee of Safety of the State of New York, 1775–1777,* 2 vols. (Albany, NY: T. Weed Thurlow, 1843).

225. Russet, *Dominic Serres,* 111; and Richard K. Koke, "Forcing the Hudson River Passage, October 9, 1776," *New York Historical Society Quarterly* 36 (October 1952).

CHAPTER 10

226. Lloyd Balderston, *The Evolution of the American Flag from Materials Collected by the Late George Canby* (Philadelphia: Ferris and Leach, 1909), 49, contends that the American flag was made by Betsy Ross (Mrs. Claypoole) shortly before the Declaration of Independence. Smith, *Long May It Wave,* 4, denotes June 14, 1777, as the date of the first Stars and Stripes.

227. "The British opened direct negotiations [for peace] with the American peace commissioners in Paris on April 12. Formal negotiations began on September 27, and the preliminary articles of peace were signed on November 30, 1782. . . . The British announced the end of hostilities on February 4, 1783." Furlong and McCandless, *So Proudly We Hail,* 144. See also Richard B. Morris, *The Peacemakers: The Great Powers and American Independence* (New York: Harper & Row, 1965); and Ronald Hoffman and Peter J. Albert, *Peace and the Peacemakers: The Treaty of 1783* (Charlottesville: University Press of Virginia, 1986).

228. Moeller, *Shattering an American Myth,* 136.

229. A flag bearing rows of stars is more visible at a greater distance than a flag bearing a circle of stars. Because the early American flag was primarily used for naval identification and communication, the US Navy likely preferred flags with rows of stars rather than flags with a circle of stars.

230. Moeller, "One Sovereign Flag," 174.

EPILOGUE

231. John Bartlett and Emily Morison Beck, *Familiar Quotations* (Boston: Little, Brown, 1980), 760.

232. Hastings, *Life and Works of Francis Hopkinson,* 143–144; and Thomas Newton, *Dissertations on the Prophecies,* vol. 3 (London: J. R. Tonson, 1758).

233. Hastings, *Life and Works of Francis Hopkinson,* 143–144.

234. Newton, *Dissertations on the Prophecies.*

235. Clarence Williams Miller, *Benjamin Franklin's Philadelphia Printing, 1728–1766: A Descriptive Bibliography* (Philadelphia: American Philosophical Society, 1964).

236. Diego Lopez, *Declaracion Magistral Sobre las Emblemas de Andres Alciato 1655* (Menston, Yorkshire: Scholar Press, 1973).

237. Fitzpatrick, *Writings of George Washington,* 2:344, note 6.

238. Shields, *American Aeneas,* 190–191.

239. Prown, *Art as Evidence.*

240. Lorrain, *Liber Veritatis*; and Mark Purcell, William Hale, and David Pearson, *Treasures from Lord Fairhaven's Library at Anglesey Abbey* (London: Scala, 2013).

241. Jackson, *Journal of Samuel Powel,* 38, 39. The arrangement of stars in Benjamin West's painting *The Woman Clothed with the Sun Fleeth from the Persecution of the Dragon,* circa 1797, commissioned by William Beckford for Fonthill Abbey, indicates that West might have been aware of American flag thirteen-star symbolism. See Nancy L. Pressley, *Revealed Religion: Benjamin West's Commissions for Windsor Castle and Fonthill Abbey* (San Antonio: San Antonio Museum of Art, 1983), 63; and John Wilmerding, *American Art in the Princeton University Art Museum* (Princeton: Princeton University Press, 2004), 65.

APPENDIX A

242. J. A. Leo Lemay, "The American Aesthetic of Franklin's Visual Creations," *Pennsylvania Magazine of History and Biography* 8 (1987): 465–499; and Newman, *Early Paper Money,* 24, 58, 74, 75, identify the principal sources of authors of emblems and mottoes on American paper currency.

243. Karen Severud Cook, "Benjamin Franklin and the Snake that Would Not Die," in *Images and Icons of the New World: Essays on American Cartography,* ed. Karen Severus Cook (London: British Library, 1996), 88–111.

244. Lemay, "American Aesthetic of Franklin's Visual Creations"; and Newman, *Early Paper Money.* Six of the seven designs were derived from Joachim Camerarius, *Symbolorum ac Emblematum Ethico Politicorum* (Joachim Cameraerius, 1702). (Franklin's copy of this book is in the Library Company of Philadelphia.) The seventh design was derived from Diego de Saavedra Fajardo, *Idea Principia Christiano: Politici Expressa* (1660).

245. William B. Willcox, ed., *The Papers of Benjamin Franklin,* vol. 22, *March 22, 1775–October 26, 1776* (New Haven, CT: Yale University Press, 1982).

246. Olson, *Benjamin Franklin's Vision,* 121–122.

247. Stephen Strach, "A New Look at the Regimental Colors of the Second New Hampshire Regiment 1777," *Military Collector and Historian Journal of the Company of Military Historians* 37 (Fall 1985): 129.

248. Olson, *Benjamin Franklin's Vision,* 122

APPENDIX B

249. Sabine Albersmeier, ed., *Heroes: Mortals and Myths in Ancient Greece* (Baltimore: Walters Museum, 2010) provides a description of this Tyrrhenian amphora (184) and a contemporary description of the robe, known as a *peplos* (53–54). See also Louis Rawlings and Hugh Bowden, eds., *Herakles and Hercules: Exploring a Greco-Roman Divinity* (Swansea, MA: Classical Press, 2005).

250. Earl P. Williams, "The Fancy Work of Francis Hopkinson: Did He Design the Stars and Stripes?" *Prologue* 20, no. 1 (Spring 1988): 42–52; and Donald W. Holst, "Notes on Continental Artillery Flags and Flag Guns: Part I," *Journal of the Company of Military Historians* 46, no. 3 (Fall 1994): 122–127. See also Egbert, "General Mercer at the Battle of Princeton."

References

Adams, James Truslow, ed. *Album of American History: Colonial Period.* New York: Scribner's Sons, 1944.

Albersmeier, Sabine, ed. *Heroes: Mortals and Myths in Ancient Greece.* Baltimore: Walters Museum, 2010.

Alberts, Robert C. *Benjamin West: A Biography.* Boston: Houghton Mifflin, 1978.

Alciati, Andrea. *Declaracion Magistral Sobre la Emblemas de Andres Alciato.* Menston: Scolar Press, 1973.

Altieri, Ferdinando. *Dizionario Italiano ed Inglese [A Dictionary of Italian and English].* London: William and John Innys, 1726–1727.

Amedick, Rita. "Der Child des Achilleus in der Hellenistisch-Romischen Ikonographischen Tradition." *Jahrbuch des Deutschen Archaologischen Instituts* 14 (1999): 157–206.

Anderson, William S. *The Art of the Aeneid.* New York: Prentice Hall, 1969.

Ansoff, Peter. "Sir Charles Fawcett Redux: The Historical Connection between the East India Flag and the American Continental Colors." *Proceedings of the 24th International Congress of Vexillology*, Washington, DC (Aug. 1–5, 2011).

Ayto, John. *Dictionary of Word Origins.* New York: Arcade, 1993.

Bailyn, Bernard. *To Begin the World Anew: The Genius and Ambiguities of the American Founders.* New York: Vintage, 2003.

Balderston, Lloyd. *The Evolution of the American Flag from Materials Collected by the Late George Canby.* Philadelphia: Ferris and Leach, 1909.

Bannon, Cynthia J. *The Brothers of Romulus: Fraternal Pietas in Roman Law, Literature and Society.* Princeton: Princeton University Press, 1997.

Barber, Richard. *King Arthur: Hero and Legend.* Woodbridge, Suffolk: Boydell, 2004.

Barnes, Jonathan, ed. *The Complete Works of Aristotle: The Revised Oxford Translation.* Princeton: Princeton University Press, 1984.

Barney, Stephen A., W. J. Lewis, J. A. Beach, and Oliver Berghof, eds. *The Etymologies of Isadore of Seville.* Cambridge, UK: Cambridge University Press, 2006.

Bartlett, John, and Emily Morison Beck. *Famous Quotations.* Boston: Little Brown, 1980.

Bartsch, Adam. *The Illustrated Bartsch.* New York: Abaris, 1985.

Bartusiak, Marcia. *Archives of the Universe: A Treasury of Astronomy's Historic Works of Discovery.* New York: Pantheon, 2004.

Battistini, Matilde. *Symbols and Allegories in Art: A Guide to Imagery,* Stephen Sartarelli, trans. Los Angeles: J. Paul Getty Museum, 2002.

Beck, James H. *Raphael.* New York: Harry N. Abrams, 1994.

Becker, Udo. *The Continuum Encyclopedia of Symbols.* New York: Continuum, 1994.

Benson, George Willard. *The Cross: Its History and Symbolism.* Mineola: Dover, 2005.

Benton, Josiah Henry. *John Baskerville: Type-Founder and Printer, 1706–1775.* Boston: Privately Printed, 1914.

Bishop, M.C., and J. C. N. Coulston. *Roman Military Equipment: From the Punic Wars to the Fall of Rome, 2nd ed.* Oxford: Oxbow, 2006.

Blunt, Anthony. *Art and Architecture in France: 1500 to 1700.* Hammondsworth: Penguin, 1957.

Bordeleau, André G. *Flags of the Night Sky: When Astronomy Meets National Pride.* London: Springer, 2014.

Boss, Sarah Jane, ed. *Mary: The Complete Resource.* New York: Oxford University Press, 2007.

Brashear, Ronald, and Daniel Lewis. *Star Struck: One Thousand Years of the Arts and Science of Astronomy.* Seattle: University of Washington Press, 2001.

Bray, William, ed. *The Diary of John Evelyn. Esq., F.R.S. from 1641 to 1705–06: With Memoir.* London: Henry Colburn, 1857.

British Museum. *A Guide to the Antiquities of Roman Britain.* London: British Museum, 1922.

Bullock, Steven C. *Revolutionary Brotherhood: Freemasonry and the Transformation of the American Social Order, 1730–1840.* Chapel Hill: University of North Carolina Press, 1996.

Burton, E. Milby. *South Carolina Silversmiths, 1690–1860.* Rutland, VT: C. Tuttle, 1968.

Cadou, Carol B. *The George Washington Collection: Fine and Decorative Arts at Mount Vernon.* Manchester: Hudson Hills Press, 2006.

Callahan, Charles H. *Washington: The Man and the Mason.* Whitefish, MT: Kessinger, 1913.

Canby, George, and Lloyd Balderstein. *The Evolution of the American Flag.* Philadelphia: Ferris & Leach, 1909.

Castleden, Rodney. *King Arthur: The Truth Behind the Legend.* New York: Routledge, 1999.

Chapin, Howard M. *Illustrations of the Seals, Arms, and Flags of Rhode Island.* Providence: Rhode Island Historical Society, 1930.

Chase, George Henry. "The Shield Devices of the Greeks." *Harvard Studies in Classical Philology* 13 (1902): 1–127.

Cicero, Marcus Tullius, Niall Rudd, and J. G. F. Powell. *The Republic and the Laws.* New York: Oxford University Press, 1998.

Cirlot, J. E. *A Dictionary of Symbols.* New York: Philosophical Library, 2002.

Connelly, Joan Breton. *The Parthenon Enigma.* New York: Knopf, 2014.

Cook, Karen Severud, "Benjamin Franklin and the Snake that Would Not Die." In *Images and Icons of the New World: Essays on American Cartography,* edited by Karen Severud Cook, 88–111. Cambridge: University Press, 1996.

Cooper, Grace Rogers. *Thirteen-Star Flags: Keys to Identification.* Washington, DC: Smithsonian Institution Press, 1973.

Cooper, J. M., ed.. *Plato: Complete Works.* Indianapolis and Cambridge: Hackett, 1997.

Coppa, Frank J. *Encyclopedia of the Vatican and Papacy.* Westport, CT: Greenwood, 1999.

Coronelli, Vincenzo Maria. *Mare del Nord, 1680* (cartouche). Map #105: 330, Huntingdon Library.

Corthell, Ronald, et al. *Catholic Culture in Early Modern England.* Notre Dame: University of Notre Dame Press, 2007.

Crampton, William. *Flags of the World: A Pictorial History.* New York: Dorset, 1990.

Cranch, Chistopher Pearse, trans. *The Aeneid of Virgil.* New York: Barnes & Noble, 2007.

Darly, Matthias. *Two Rebuses from the American Revolution in Facsimilie.* Washington, DC: US Library of Congress, 1973.

Delanglez, Jean. "Franquelin, Mapmaker." *Mid America: An Historical Review* 25, no. 14 (1943): 29–74.

Desportes, Ulysse. "Guiseppe Ceracchi in America and His Busts of George Washington." *Art Quarterly* (summer 1963).

De Visscher, Eva. "Marian Devotion in the Latin West in the Latter Middle Ages." In *Mary: The Complete Resource,* edited by Sarah Jane Boss, 171–201. New York: Oxford University Press, 2007.

Dexter, Franklin B. *The Literary Diary of Ezra Stiles, D.D., L.L.D., President of Yale College,* New York: C. Scribner's Sons, 1901.

Dictionary of Canadian Biography. Toronto: University of Toronto Press, 1969.

Dodds, Monica, and Bill Dodds. *Encyclopedia of Mary.* Huntington, IN: Our Sunday Visitor, 2007.

Dolmetsch, Joan D. *Rebellion and Reconciliation: Satirical Prints on the Revolution at Williamsburg.* Charlottesville: University Press of Virginia, 1976.

Driskel, Michael Paul. "By the Light of Providence: The Glory

Altarpiece at St. Paul's Chapel, New York City." *Art Bulletin* 89, no. 4 (December 2007): 715–737.

Druckman, Nancy. *American Flags: Designs for a Young Nation.* New York: Harry N. Abrams, 2003.

Duchet-Suchaux, Gaston, and Michel Pastoureau. "The Bible and the Saints." *The Art Book* 2, no. 1 (January 1995), 18a.

Du Choul, Guilluame. *Veterum Romanorum Religio: Catrametatio, Disciplina Militaris ut & Balnae.* Amsterdam: Janssonio-Waesbergios, 1686.

Dussler, Luitpold. *Raphael: A Critical Catalogue of His Pictures, Wall Paintings and Tapestries.* London: Phaidon, 1971.

Edson, E., and E. Savage-Smith. *Medieval Views of the Cosmos.* Oxford: Bodleian Library, 2004.

Egbert, Donald. "General Mercer at the Battle of Princeton as Painted by James Peale, Charles Willson Peale and William Mercer." *Princeton University Library Chronicle* 8, no. 4 (summer 1952): 171–194.

Elder, Charles D., and Roger W. Cobb. *The Political Uses of Symbols.* New York: Longman, 1983.

Ellery, William. "Diary of the Hon. William Ellery of Rhode Island, June 28–July 23, 1778." *Pennsylvania Magazine of History and Biography (1877–1906)* 11, no. 4: 476.

Ellis, Joseph J. *Founding Brothers: The Revolutionary Generation.* New York: Vintage, 2002.

Encyclopedia Americana. Danbury, CT: Grolier, 1994.

Evans, Ivor H. *Brewer's Dictionary of Phrase and Fable.* New York: Harper & Row, 1981.

Exhibition of Portaits by Charles Willson Peale and James Peale, and Rembrant Peale. Philadelphia: Pennsylvania Academy of the Fine Arts, 1923.

Faber, Riemer. "Vergil's 'Shield of Aeneas' and the Shield of Heracles." *Mnemosyne* 53 (2000).

Fagles, Robert, trans. *The Aeneid.* New York: Penguin, 2006.

——. *The Iliad.* New York: Penguin, 1998.

Fawcett, Charles. "The Striped Flag of the East India Company and Its Connexion with the American 'Stars and Stripes.' " *Mariner's Mirror* 23 (1939): 449–476.

Ferber, Michael. *A Dictionary of Literary Symbols.* Cambridge: Cambridge University Press, 2007.

Ferguson, George. *Signs and Symbols in Christian Art.* London: Oxford University Press, 1961.

Firth, Raymond. *Symbols Public and Private.* London: George Allen & Unwin, 1973.

Fischer, David H. *Liberty and Freedom: A Visual History of America's Founding Ideas.* New York: Oxford University Press, 2005.

Fisher, George. *American Instructor.* Philadelphia: B. Franklin and D. Hall, 1748.

Fitzpatrick, John C., ed. *The Writings of George Washington from the Original Manuscript Sources, 1745–1799.* 39 vols. Washington, DC: US Government Printing Office, 1931–44.

Fleming, E. McClung. "The American Image as Indian Princess, 1765–1783." *Winterthur Portfolio* II (1965): 65–81.

Fontana, David. *The Secret Language of Symbols: A Visual Key to Symbols and their Meanings.* San Francisco: Chronicle Books, 1994.

Ford, Worthington C., et al., eds. *Journals of the Continental Congress, 1774–1789.* Washington, DC: US Government Printing Office, 1904–37.

Furlong, William R., and Byron McCandless. *So Proudly We Hail: The History of the United States Flag.* Washington, DC: Smithsonian Institution Press, 1981.

Gadon, Elinor. *The Once and Future Goddess: A Symbol for Our Time.* New York: Harper and Collins, 1989.

Galbreath, Donald L. *A Treatise on Ecclesiastical Heraldry, Part I Papal Heraldry.* Cambridge: W. Heffer and Sons, 1930.

Garraty, James A., and Mark C. Carnes. *American National Biography.* New York: Oxford University Press, 1999.

Gatta, John. *American Madonna: Images of the Divine Woman in Literary Culture.* New York: Oxford University Press, 1997.

Geoffrey of Monmouth. *Histories of the Kings of Britain.* London: J. M. Dent and Sons, 1944.

George Washington at Princeton: Property from the Collection of Mrs. J, Insley Blair, Saturday 21 January 2006. New York: Christie's, 2006.

Goold, G. P., ed. *Manilius: Astronomica.* Cambridge, MA: Harvard University Press, 2006.

Graves, Robert. *The White Goddess: A Historical Grammar of Poetic Myth.* New York: Farrar, Straus, and Giroux, 1948.

Grimal, Pierre. *The Dictionary of Classical Mythology.* Malden, ME: Blackwell, 1996.

Griscom, Acton. *The Historia Regum Britanniae of Geoffrey of Monmouth.* London: Langman, Green, 1929.

Guenther, Scot M. *The American Flag, 1777–1924: Cultural Shifts from Creation to Codification.* Rutherford: Fairleigh Dickinson University Press, 1990.

Guide Book and Descriptive Manual of Battle Flags in Flag Room of State-House at Annapolis, Maryland. Annapolis, MD: Reckford, Milton Atchison, 1934.

Hall, James. *Dictionary of Subjects and Symbols in Art.* New York: HarperCollins, 1994.

Hamilton, John D. *Material Culture of the American Freemasons.* Lexington, MA: Museum of Our National Heritage, 1994.

Hamilton, Schuyler. *Our National Flag—The Star-Spangled Banner: The History of It.* New York: Lockwood, 1887.

Hamilton, Sinclair. "The Earliest Devices of the Colonies and Some Other Early Devices." *Princeton University Library Chronicle* 10, no. 3 (April 1949): 117–123.

Hamilton, Stanislaus M. *Letters to Washington and Accompanying Papers vol. 5 (1774–1775).* Cambridge: Riverside, 1902.

Hardie, Philip. *Virgil's Aeneid: Cosmos and Imperium.* Oxford: Oxford University Press, 2003.

Harrison, Peleg D. *The Stars and Stripes and Other American Flags.* Boston: Little Brown, 1906.

Hartley, Elizabeth, Jane Hawkes, Martin Henig, and Francis Mee, eds. *Constantine the Great: York's Roman Emperor.* Marygate: York Museum Trust, 2006.

Hastings, George E. *The Life and Works of Francis Hopkinson.* Chicago: University of Chicago, 1926.

Hawkins, Henry. *Partheneia Sacra.* Brookfield, VT: Scolar Press/Ashgate, 1993.

Heckscher, Morrison H., and Leslie G. Bowman. *American Rococo, 1750–1775: Elegance in Ornament.* New York: Henry N. Abrams, 1992.

Heisser, David C. R. "Warrior Queen of the Ocean: The Story of Charleston and Its Seal." *South Carolina Historical Magazine* 93, no. 3–4 (1992): 167–195.

Hindle, Brooke. *David Rittenhouse.* New York: Arno, 1980.

Hoffman, Ronald, and Peter J. Albert, eds. *Peace and the Peacemakers: The Treaty of 1783.* Charlottesville: University Press of Virginia, 1986.

Hoobler, Dorothy, and Thomas Hoobler. *Captain John Smith: Jamestown and the Birth of the American Dream.* Hoboken, NJ: John Wiley, 2006.

Holst, Donald W. "Notes on Continental Artillery Flags and Flag Guns: Part I." *Journal of the Company of Military Historians* 46, no. 3 (fall 1994): 122–127.

Holtgen, Karl Josef. "Introduction." In Henry Hawkins, *Partheneia Sacra.* Brookfield, VT: Scolar Press/Ashgate, 1993.

Hood, Graham. "Easy, Erect and Noble." *Journal of the Colonial Williamsburg Foundation* 24, no. 2 (summer 2002): 52–57.

Hope, Jane. *The Secret Language of the Soul: A Visual Guide to the Spiritual World.* San Francisco: Chronicle Books, 1997.

Hornblower, Simon, and Anthony Spawforth. *The Oxford Classics Dictionary.* Oxford and New York: Oxford University Press, 1996.

Hoskin, Michael. *Discoverers of the Universe: William and Caroline Herschel.* Princeton: Princeton University Press, 2011.

Hughes, Robert. *Rome: A Cultural, Visual, and Personal History.* New York: Alfred K. Knopf, 2011.

Hutson, James H. *The Founders on Religion: A Book of Quotations.* Princeton: Princeton University Press, 2005.

The Interpreter's Bible. New York: Abingdon-Cokesbury, 1951–1957.

J. Paul Getty Handbook of the Antiquities Collection. Los Angeles: Getty Publications, 2002.

Jackson, Sarah, ed. *A Journal of Samuel Powell (Rome 1764).* Florence: Studio per Edizioni Scelte, 2001.

Jacobs, Phoebe Lloyd. "John James Barralet and the Apotheosis of George Washington." In *Winterthur Portfolio* no. 12 (1977): 115–137.

James, Charles. *A New and Enlarged Military Dictionary, in French and English,* 3rd ed. London: T. Egerton, Military Library, 1810.

James, E. O. *The Cult of the Mother-Goddess: An Archaeological and Documentary Study*. New York: Prager, 1959.

Jameson, Anna Brownell. *Legends of the Madonna: As Represented in the Fine Arts*. New York: Charles L. Bowman, 1890.

Jewel, Elizabeth, and Frank Abate, eds. *The New Oxford American Dictionary.* New York: Oxford University Press, 2001.

Johnson, Samuel. *A Dictionary of the English Language,* 4th ed., vol. 1. London: W. Strahan, 1775.

Jones, Bernard E. *Freemason's Guide and Compendium.* Nashville: Cumberland House, 2006.

Jordan, Michael. *Encyclopedia of Gods: Over 2,500 Deities of the World.* New York: Facts on File, 1993.

Journals of the Provincial Congress, Provincial Convention, Committee of Safety of the State of New York, 1775–1777, 2 vols. Albany, NY: T. Weed Thurlow, 1843.

Jowett, Benjamin, trans. *Timeus*. London: Akasha, 2008.

Judge, Michael. *The Dance of Time: The Origins of the Calendar.* New York: Arcade, 2004.

Kaye, Ted. *Good Flag, Bad Flag: How to Design a Great Flag.* Trenton, NJ: North American Vexillogical Association, 2006.

Keim, Kevin, and Peter Keim. *A Grand Old Flag: A History of the United States Through Its Flags.* New York: DK, 2007.

Kelso, William M. *Jamestown: The Buried Truth.* Charlottesville: University of Virginia Press, 2006.

Kitson, Michael. "The 'Altieri Claudes' and Virgil." *Burlington Magazine* 102, no. 688 (1960): 312–318.

Knill, Harry. *The Story of Our Flag.* Santa Barbara, CA: Bellerophon, 1999.

Konig, Thomas. *Le Politique Hollandais.* Amsterdam: J. A. Crajenschat & A. M. Cerisier, 1781.

Lachieze-Rey, Marc, and Jean-Pierre Luminet. *Celestial Treasury: From the Music of the Spheres to the Conquest of Space.* Cambridge: Cambridge University Press, 2001.

Leepson, Marc. *Flag: An American Biography.* New York: St. Martin's, 2005.

Lehner, Ernest, and Johanna Lehner. *Astrology and Astronomy: A Pictorial Archive of Signs and Symbols.* Mineola, NY: Dover, 1992.

Lemay, J. A. Leo. "The American Aesthetics of Franklin's Visual Creation." *Pennsylvania Magazine of History and Biography* 8 (1987): 465–499.

Liungman, Carl G. *A Dictionary of Symbols.* Malmo, Santa Barbara: ABC-CLIO, 1991.

Lopez, Diego. *Declaracion Magistral Sobre las Emblemas de Andres Alciato 1655.* Menston, Yorkshire: Scholar Press, 1973.

Lorrain, Claude. *Liber Veritatis, or, A Collection of Prints, After the Original Designs of Claude Lorrain.* London: Hurst, Robinson, and Co., 1819.

Loubat, J. F. *The Medallic History of the United States of America 1776–1876.* New York: J. F. Loubat, 1878.

Mackrell, Alice. *Shawls, Stoles and Scarves.* London: B. T. Batsford, 1986.

Madaus, Howard M. "Nova Constellatio: The Story of a Shared Heritage." *The Numismatist* (February 1983): 238–245.

Madaus, Howard, and Whitney Smith. *The American Flag: Two Centuries of Concord and Conflict.* Santa Cruz: VZ Publications, 2006.

Mader, Peter M., and Gunter Mattern. *Fahnen und ihre Symbole.* Zurich: Schweizerisches Landsmuseum: 1993.

Mantin, Peter, and Ruth Mantin. *The Islamic World: Beliefs and Civilizations 600–1600.* Cambridge: Cambridge University Press, 1993.

March, Jennifer, ed. *Cassell Dictionary of Classical Mythology.* London: Wellington House, 1998.

Marvin, Carolyn, and David W. Ingle, eds. *Blood Sacrifice and the Nation: Totem Rituals and the American Flag.* Cambridge, UK and New York : Cambridge University Press, 1999.

Mastai, Boleslaw, and Marie-Louise D'Otrange Mastai. *The Stars and the Stripes: The American Flag as Art and as History from the Birth of the Republic to the Present.* New York: Alfred A. Knopf, 1973.

Matthews, Marty D. *Forgotten Founder: The Life and Times of Charles Pickney.* Columbia: University of South Carolina Press, 2004.

McArthur, Meher. *Reading Buddhist Art: An Illustrated Guide to Buddhist Signs and Symbols.* New York: Thames & Hudson, 2002.

McConkey, James H. *The Book of Revelation.* Pittsburgh: Silver Publishing Society, 1921.

McCullough, David. *The American Spirit: Who We Are and What We Stand For.* New York: Simon & Schuster, 2017.

McConville, Brendan. *The King's Three Faces: The Rise and Fall of Royal America, 1688–1776.* Chapel Hill: University of North Carolina Press, 2006.

Metford, J. C. *Dictionary of Christian Lore and Legend.* London: Thames & Hudson, 1983.

Middle English Dictionary, http://quod.lib.umich.edu/m/mec/.

Miller, Clarence Williams. *Benjamin Franklin's Philadelphia Printing, 1728–1766: A Descriptive Bibliography.* Philadelphia: American Philosophical Society, 1964.

Miller, Lillian B., ed. *The Selected Papers of Charles Willson Peale and His Family.* New Haven: Yale University Press, 1983.

Miller, Marla R. *Betsy Ross and the Making of America.* New York: Henry Holt, 2010.

Moeller, Henry W. "One Sovereign Flag: With Multiple Designs and Uses." *NAVA News,* 35, no. 2 (2002): 2–5.

———. *Shattering an American Myth: Unfurling the History of the Stars and Stripes,* 2nd ed. Mattituck, NY: Amereon, 1995.

Montgomery, Charles F., and Patricia E. Kane. American Art 1750–1800: Towards Independence. New Haven: Yale University Press, 1976.

Morgan, John, and Julia Morgan Harding. *The Journal of Dr. John Morgan, of Philadelphia, from the City of Rome to the City of London, 1764.* Philadelphia: Lippincott, 1907.

Morgan, John Hill. *Paintings by John Trumbull at Yale University.* New Haven: Yale University Press, 1926.

Morgan, Sylvanus. *The Sphere of Gentry.* London: William Leybourn, 1661.

Mormando, Franco. *Bernini: His Life and His Rome.* Chicago: University of Chicago Press, 2011.

Morris, Richard B. *The Peacemakers: The Great Powers and American Independence.* New York: Harper and Row, 1965.

Neubecker, Ottfried. *Heraldry Sources, Symbols, and Meaning.* New York: Mc-Graw Hill, 1976.

Neumann, Erich. *The Great Mother: An Analysis of the Archetype.* Princeton: Princeton University Press, 1963.

Neumann, George C., and Frank J. Kravic. *Collector's Illustrated Encyclopedia of the American Revolution.* Texarkana: Scurlock, 1975.

New Catholic Encyclopedia, 2nd ed. Detroit: Thomson/Gale, 2003.

New Interpreter's Bible. Nashville: Abingdon-Cokesbury, 1994–2002.

Newman, Eric P. *The Early Paper Money of America.* Iola, WI: Kraus, 1997.

Newton, Thomas. *Dissertations on the Prophecies.* London: J. and R. Tonson, 1758.

Nicoll, W. Robertson, ed. *The Expositor's Greek Testament.* Grand Rapids, MI: Eerdmans, 1951.

Nipper, Will. I*n Yankee Doodle's Pocket: The Myth, Magic, and Politics of Money in Early America.* Conway, AR: Bowmanstone, 2008.

Oberg, Barbara B., and Julian Parks Boyd, eds. *The Papers of Thomas Jefferson,* vol. 33, 17 February to 30 April, 1801. Princeton: Princeton University Press, 2006.

Oberhuber, Konrad. *Raphael: The Paintings.* Munich: Prestel Verlag, 1999.

O'Connor, Edward D. *The Dogma of the Immaculate Conception: History and Significance.* Notre Dame, IN: University of Notre Dame Press, 1958.

Olson, Lester C. *Benjamin Franklin's Vision of American Community: A Study in Rhetorical Iconology.* Columbia: University of South Carolina Press, 2004.

Olson, Lester C. *Emblems of American Community in the*

Revolutionary Era: A Study in Rhetorical Iconology. Washington, DC: Smithsonian Institution Press, 1991.

Ovason, David. *The Secret Architecture of Our Nation's Capital.* London: Century Books, 1999.

Pastoureau, Michel. *The Devil's Cloth: A History of Stripes and Striped Fabric.* New York: Columbia University Press, 1991.

Patterson, Richard S., and Richardson Dougall. *The Eagle and the Shield: A History of the Great Seal of the United States.* Washington, DC: US Government Printing Office, 1976.

Pell, Stephen. "The Gorget as a Defense, as a Symbol, and as an Ornament." *The Bulletin of Fort Ticonderoga Museum,* 4, no. 23 (Sep. 1937): 126–141.

Peterson, Charles E. *The Rules of Work of the Carpenter's Company of the City and County of Philadelphia (1786).* Princeton: Pyne Press, 1971.

Peterson, Harold L. *Arms and Armor in Colonial America, 1526–1783.* Mineola, NY: Dover, 2000.

———. *The Book of the Continental Soldier.* Harrisburg, PA: Stackpole, 1968.

Pitch, Anthony S. *The Burning of Washington: The British Invasion of 1814.* Annapolis: Naval Institute Press, 1998.

Pope, Alexander, trans. *The Iliad of Homer* (six volumes). London: W. Bowyer Bernard Linton, 1715–20.

Poschl, Viktor. *The Art of Vergil.* Ann Arbor: University of Michigan Press, 1970.

Preble, George H. *History of the Flag of the United States of America,* 2nd ed. Boston: A. Williams, 1880.

Preston, Percy. *A Dictionary of Pictorial Subjects from Classical Literature: A Guide to Their Identification in Works of Art.* New York: Charles Scribner's Sons, 1983.

Price, Simon, and Peter Thonemann, *The Birth of Classical Europe: A History from Troy to Augustine.* New York: Viking, 2010.

Prime, Alfred Coxe. *The Arts and Crafts in Philadelphia, Maryland and South Carolina: 1721–1785.* New York: The Walpole Society, 1929.

Prown, Jules David. *Art As Evidence: Writings on Art and Material Culture.* New Haven, CT: Yale University Press, 2001.

Quaife, Milo M. *The History of the United States Flag.* New York: Harper and Row, 1961.

Rapelli, Paola. *Symbols of Power in Art.* Los Angeles: J. Paul Getty Museum, 2004.

Reeves, Eileen. *Painting the Heavens: Art and Science in the Age of Galileo.* Princeton: Princeton University Press, 1997.

Reid, Jane Davidson, and Chris Rohmann. *The Oxford Guide to Classical Mythology in the Arts, 1300–1900s.* New York: Oxford University Press, 1993.

Reilly, Elizabeth Carroll. *A Dictionary of Colonial American Printers' Ornaments and Illustrations.* Wochester, MA: American Antiquarian Society, 1975.

Reinhold, Meyer. *Classical Americana: The Greek and Roman Heritage in the United States.* Detroit: Wayne State University Press, 1984.

Rhodehamel, John. *The Great Experiment: George Washington and the American Republic.* New Haven: Yale University Press: 1998.

Richard, Carl J. *The Founders and the Classics: Greece, Rome and the American Enlightenment.* Cambridge: Harvard University Press, 1995.

Richardson, Edward W. *Standards and Colors of the American Revolution.* Philadelphia: University of Pennsylvania Press, 1982.

Rietstap, Johannes B. *Armorial General: Precede d un Dictionnaire des Termed du Blazon,* vol. 1. Baltimore: Genealogical Publishing, 1972.

Roberts, Helene E. *Encyclopedia of Comparative Iconography,* 2 vols. Chicago: Fitzroy Dearborn, 1998.

Roberts, John, ed. *The Oxford Dictionary of the Classical World.* New York: Oxford University Press, 2007.

Ronnberg, Ami, ed. *The Book of Symbols: Reflections on Archetypal Images.* Cologne, Germany: Taschen, 2010.

Rosenberg, Donna. *World Mythology: An Anthology of the Great Myths and Epics.* Lincolnwood, IL: NTC, 1994.

Rothlisberger, Marcel. *Claude Lorrain: The Paintings.* New Haven: Yale University Press, 1961.

Ruggles, Clive. *Ancient Astronomy: An Encyclopedia of Cosmologies and Myth.* Santa Barbara: ABC CLIO, 2005

Russet, Alan: *Dominic Serres (1719–1793): War Artist to the Navy.* Woodbridge, Suffolk: Antique Collector's Club, 2001.

Ryken, Leland, James C. Wilhoit, and Tremper Longman III. *Dictionary of Biblical Imagery.* Downers Grove, IL: Inter Varsity, 1998.

Sandoz, Ellis, ed. *Political Sermons of the American Founding Era (1730–1805).* Indianapolis: Liberty Press, 1991.

Scherer, Margaret R. *The Legends of Troy in Art and Literature.* New York: Phaidon, 1963.

Schermerhorn, Frank Earle. *American and French Flags of the Revolution, 1775–1783.* Philadelphia: Pennsylvania Society of Sons of the Revolution, 1948.

Schlenther, Boyd Stanley. *Charles Thomson: A Patriot's Pursuit.* Newark: University of Delaware Press, 1990.

Scott, Pamela. *Temple of Liberty: Building the Capitol for a New Nation.* New York: Oxford University Press, 1995.

Sellers, Charles Coleman. *The Artist of the Revolution: The Early Life of Charles Willson Peale.* Hebron, CT: Feather and Good, 1939.

Serres, Dominick, and John Thomas Serres, *Liber Nauticus and Instructor in the Art of Marine Drawing.* London: Scolar, 1979.

Shalev, Eran. "A Republic Amidst the Stars: Political Astronomy and the Intellectual Origins of the Stars and Stripes." *Journal of the Early Republic* 31, no. 1 (spring 2011): 39–73.

Sheperd, Rowena, and Frank Sheperd. *1000 Symbols: What Shapes Mean in Art and Myth.* New York: Thames & Hudson, 2002.

Sherwood, Samuel. "The Church's Flight into the Wilderness [1776]." In *Political Sermons of the American Founding Era, 1730–1805,* 2nd ed., vol. 1, edited by Ellis Sandoz, 493–527. Indianapolis: Liberty Fund, 1998.

Shields, John C. *The American Aeneas: Classical Origins of the American Self.* Knoxville: University of Tennessee Press, 2001.

Shipton, Clifford K., and James E. Mooney. *National Index of American Imprints Through 1800. The Short-Title Evans.* Worcester, MA: American Antiquarian Society and Barre Publishers, 1969.

Simmons, Linda Crocker. *Charles Peale Polk, 1776–1822.* Washington, DC: Corcoran Gallery of Art, 1981.

Skeat, Walter W. *An Entymologial Dictionary of the English Language.* Oxford: Clarendon, 1963.

Smith, Page. *A New Age Now Begins,* vol. 1. New York: McGraw-Hill, 1976.

Smith, Whitney. *The Flag Book of the United States.* New York: William Morrow, 1975.

———. *Flags Through the Ages and Across the World.* New York: McGraw-Hill, 1975.

Smith, Whitney, and Peter Orenski. *Long May It Wave! The National Flag of the United States Past, Present and Future.* Winchester, MA: Flag Research Center, 1998.

Smith, William, and Theophilus D. Hall. *A Copious and Critical English-Latin Dictionary: A Dictionary of Proper Names.* New York: American Book Company, 1871.

Snodgrass, Mary Ellen. *Signs of the Zodiac: A Reference Guide to Historical, Mythological, and Cultural Associations.* Westport, CT: Greenwood, 1997.

Sommer, Frank H. "Emblem and Device: The Origin of the Great Seal of the United States." *Art Quarterly* 24 , no. 1 (1961): 57–76.

Sondheim, Moriz. "Shakespeare and the Astrology of His Time." *Journal of the Warburg Institute* 2, no. 3 (January 1939): 243–259.

Spivey, Nigel, and Michael Squire. *Panorama of the Classical World.* Los Angeles: J. Paul Getty Museum, 2004.

Staal, Julius. *The New Patterns in the Sky: Myths and Legends of the Stars.* Blacksburg, VA: McDonald and Woodward, 1988.

Stevens, Anthony. *Ariadne's Clue: A Guide to the Symbols of Humankind.* Princeton: Princeton University Press, 1998.

Stevenson, Thomas B. *Miniature Decoration in the Vatican Virgil: A Study in Late Antique Iconography.* Tubignen: Verlog E.

Wasmuth, 1983.

Stiles, Ezra. *The United States Elevated to Glory and Honor,* 2nd ed. Worcester, MA: Isaiah Thomas, 1785.

Strach, Stephen G. "A New Look at the Regimental Colors of the Second New Hampshire Regiment 1777." *Military Collector and Historian,* 37 (fall 1985): 127–134.

Strachan, Hew. *British Military Uniforms 1768–1796: The Dress of the British Army from Official Sources.* London: Ams and Armour Press, 1975.

Stone, George Cameron. *A Glossary of the Construction, Decoration and Use of Arms and Armor in All Countries and in All Times: Together with Some Closely Related Subjects.* New York: Jack Brussel, 1961.

Sutherland, C. H. V. *Roman Coins.* London: Barrie & Jenkins, 1975.

Sutton, Jean. *Lords of the East.* London: Chrysalis Group, 2000.

Tabbert, Mark A. *American Freemasons: Three Centuries of Building Communities.* New York: New York University Press, 2005.

Talbott, Page, ed. *Benjamin Franklin: In Search of a Better World.* New Haven: Yale University Press, 2005.

Teachout, Woden. *Capture the Flag: A Political History of American Patriotism.* New York: Perseus, 2009.

Tresidder, Jack. *Dictionary of Symbols.* San Francisco: Chronicle Books, 1997.

Tripp, Edward. *Crowell's Handbook of Classical Mythology.* New York: Thomas Y. Crowell, 1970.

Trofimova, Anna A. *Greeks on the Black Sea: Ancient Art from the Hermitage.* Los Angeles: J. Paul Getty Museum, 2007.

Turner, Jane, ed. *The Dictionary of Art.* New York: Grove, 1996.

Vaughan, Dorothy M. *This Was a Man: A Biography of General William Whipple.* Lunenburg, VT: Stinehour Press, 1964.

Viladesau, Richard. *The Beauty of the Cross.* New York: Oxford University Press, 2006.

Vloberg, Maurice. "The Iconographic Types of the Virgin in Western Art." In *Mary: The Complete Resource,* edited by Sarah

Jane Boss, 537–546. New York: Oxford University Press, 2007.

Vogel, Carol. "Inside Art." *New York Times.* Friday, June 24, 2005.

Volbach, W. Fritz. *Early Decorative Textiles.* London: Paul Hamlyn, 1989.

Warner, Deborah. *The Sky Explored: Celestial Cartography 1500–1800.* New York: Alan R. Liss, 1979.

Warner, Marina, and Felipe Fernandez-Armesto. *World of Myths.* Austin: British Museum Press and University of Texas Press, 2003.

Webster, Sally. *The Nation's First Monument and the Origins of the American Memorial Tradition: Liberty Enshrined.* Burlington, VT: Ashgate, 2015.

Webster's New World College Dictionary, 4th ed. Cleveland: Wiley, 2005.

White, George M. *Art in the United States Capitol.* Washington, DC: US Government Printing Office, 1976.

White, Leslie A. *The Science of Culture: A Study of Man and Civilization.* London: Forgotten Books, 2013 (reprint).

Whitfield, Peter. *Astrology: A History.* New York: Harry N. Abrams, 2001.

Wildenstein, George. *Paintings by Jean-Honore Fragonard.* London: Phaidon, 1960.

Wilkenson, Philio. *Myths and Legends.* London: DK, 2009.

Willcox, William B. *The Papers of Benjamin Franklin.* New Haven: Yale University Press, 1982.

Williams, Earl P. "The Fancy Work of Francis Hopkinson: Did He Design the Stars and Stripes?" *Prologue* 20, no. 1 (spring 1988).

Williams, Herman W. "American Silver Gorget." *Military Collector and Historian* 13, no. 2 (1961): 55.

Wilmerding, John. *American Art in the Princeton Art Museum.* New Haven: Yale University Press, 2004.

Wine, Humphrey. *Claude: The Poetic Landscape.* London: National Gallery Publications, 1994.

Winterer, Caroline. *The Culture of Classicism: Ancient Greece and Rome in American Intellectual Life, 1780–1910.* Baltimore:

John Hopkins University Press, 2002.

———. *The Mirror of Antiquity: American Women and the Classical Tradition, 1750–1900.* Ithaca: Cornell University Press, 2007.

———. "From Royal to Republican: The Classical Image in Early America." *Journal of American History* 91, no. 4 (March 2005): 1264–1290.

Wittkower, Rudolf. *Bernini: The Sculptor of the Roman Baroque.* New York: Phaidon, 2010.

Wood, Gordon S. *The Americanization of Benjamin Franklin.* New York: Penguin, 2004.

Woodcock, Thomas, and John Martin Robinson. *The Oxford Guide to Heraldry.* Oxford: Oxford University Press, 1988.

Wright, M. R. *Cosmology in Antiquity.* London: Routledge, 1996.

Yeoman, R. S. *A Guide Book of United States Coins*, 64th ed. Atlanta: Whitman, 2010.

Znamierowski, Alfred. *The World Encyclopedia of Flags: The Definitive Guide to International Flags, Banners, Standards and Ensigns.* London: Hermes House, 2002.

Zahniser, Marvin R. *Charles Cotesworth Pinckney: Founding Father.* Chapel Hill: University of North Carolina Press, 1967.

Zieber, Eugene. *Heraldry in America.* New York: Crown, 1984.

Index

Flag scholar Henry Moeller lives with his family in historic Southampton, New York, the first and oldest English settlement in New York.